BREWING IN BURTON UPON TRENT

IAN WEBSTER

AMBERLEY

First published 2018

Amberley Publishing
The Hill, Stroud
Gloucestershire, GL5 4EP

www.amberley-books.com

Copyright © Ian Webster, 2018
Maps contain Ordnance Survey data.
Crown Copyright and database right, 2018

The right of Ian Webster to be identified as
the Author of this work has been asserted in
accordance with the Copyright, Designs and
Patents Act 1988.

ISBN 978 1 4456 7054 6 (print)
ISBN 978 1 4456 7055 3 (ebook)

British Library Cataloguing in Publication Data.
A catalogue record for this book is available from
the British Library.

Typesetting by Amberley Publishing.
Printed in the UK.

Contents

Introduction

'Were it not for the vast breweries, which give life to the place, Burton would have ever remained an old-fashioned, sleepy town.'

Alfred Barnard, 1889.

The subject of brewing in Burton upon Trent is vast and has been the topic of numerous books stretching back to Victorian times. It is impossible to tell the story in a short volume such as this, so I am indebted to the photographers who have allowed me to reproduce their work: Robin Jeffcoat, who started taking photographs in 1958/59 as a young lad with a Brownie camera; Mac McCree, who rediscovered his love of photography in recent years; Philip Stanbridge, who granted me access to his collection of railway photographs; Andrew Richards for some stunning aerial images; Yvonne Bradley for her photograph of the Coopers Tavern; Thea King for the Shobnall Road maltings image; and Bill Schofield for his trussing-in picture. All other photographs, unless otherwise stated, are by the author.

I would also like to thank Stephen Sinfield at the *Burton Mail* for support, photographs and proofreading; Vannessa Winstone of the National Brewery Centre for photographs; Keith Osborne for continued access to his beer label collection; Malcolm James for his help in tracking down Printon's Brewery, proofreading and advice; Gary Summerfield for photographs, proofreading and his never-ending enthusiasm; Paul Worthington and Neil Buxton for allowing me access to their breathtaking collections of Breweriana; Kim Wilson, Mark Raven, Beth Webster and Andy Jackson for proofreading; Alex Webster for his photography skills; and Glenys Brassington, Lisa Harlow and Colston Crawford for their assistance.

Finally, thanks to my parents for their continued support and belief, as well as to my wife Netty for putting up with the mess and stress that comes with writing a book.

Ian Webster
ianjohnwebster@gmail.com

I

The Early Industry

Brewing prior to 1708

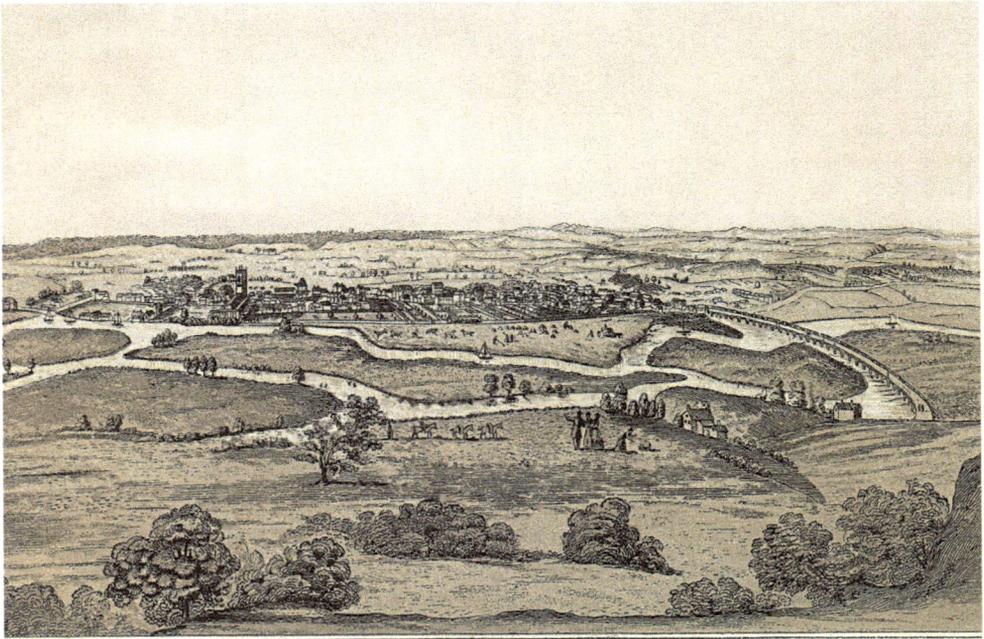

BURTON IN THE 18TH CENTURY.
(FROM AN OLD ENGRAVING)

The East Prospect of Burton-upon-Trent in the County of Stafford, S. & N. Buck (*c.* 1732). (National Brewery Centre)

Brewing in Burton upon Trent started at the Benedictine Abbey. The earliest reference to a brewhouse was 1295; however, Burton Abbey was not unusual as brewing was commonplace in these establishments. The first two people named in the historical records are 'couper' Hugh Crispe, who was granted land or property in 'Catte Streete' (later Station Street) in 1368, and brewer John Wolston in 1453.

King Henry VIII ordered the Dissolution of the Monasteries between 1536 and 1541, with Burton Abbey being dissolved in 1540. An inventory was taken detailing a brewhouse, a malthouse in the market place and other smaller malthouses elsewhere in the town, with these properties summarily passing to Sir William Paget. A letter written by Sir Amyas Paulet in April 1585 clearly shows that Paget had a brewery and a brewer at his Burton house.

A typical seventeenth-century Burton brewery was attached to an inn. These were congregated on the High Street and Horninglow Street, and there was also a brewhouse in Burton Extra. The licensees for these breweries were known as brewing victuallers.

In the mid-1650s, Peter Bunne owned much of the brewery-related properties in Burton, including the Malt Mill in the market place, the Manor House and a number of properties on the High Street. After he died in around 1665, these passed to Daniel Watson.

Until the early 1700s, Burton's brewing industry was just one of many in the town; iron-working, textiles, rope-making, wood-working, leather-working, hat-making, brick-making and alabaster carving also provided employment. The town grew from a population of 1,800 in 1710 to 50,386 in 1901, and the reason for this lay underground.

Why Burton upon Trent?

The town sits on multiple layers of siltstone and mudstone (known as the Keuper Marl), and under this a layer of gypsum that averages only 9 feet thick. It is a thin band of rock that makes the underground water supply perfectly suited for the brewing of pale ales. A shallow well less than 25 feet deep was all that was required, making it easy for early brewers to access.

High concentrations of dissolved magnesium and calcium sulphate meant hard water, which was perfect for promoting yeast growth during fermentation. It also allowed a greater quantity of hops to be added without affecting the flavour. All of this gave Burton pale ales their sparkling character.

Another type of water played a vital role, which was that of the River Trent. After the passing of the Trent Navigation Act of 1699, Burton found itself positioned on one of the country's biggest navigation systems, allowing access to the ports at Gainsborough and Hull and thereby London and other English and foreign ports, meaning Burton Ale could be sold to a wider market. The nearby coalfields in Swadlincote and Swannington fuelled the town's industry.

In Search of Benjamin Printon

Until the first decade of the eighteenth century, the brewers of Burton owned inns and sold beer brewed on the premises. The first example of a modern brewery business was run by Benjamin Printon. Established around 1708, Printon was known as a 'common brewer', meaning that his beer was sold at inns not connected to the brewing premises – the opposite of a brewing victualler. Little is known of Printon except that he was a Burtonian, baptised (and presumably born) in 1680 to Gulielmi and Maria Printon. He married twice, once in 1708 to Maria Dunnitt and then in 1725 to Elizabeth Wood. He died in 1728 and was buried in St Modwen's. After his death the brewery was bought by John Musgrove (some sources spell the name as 'Musgrave' or 'Musgreave').

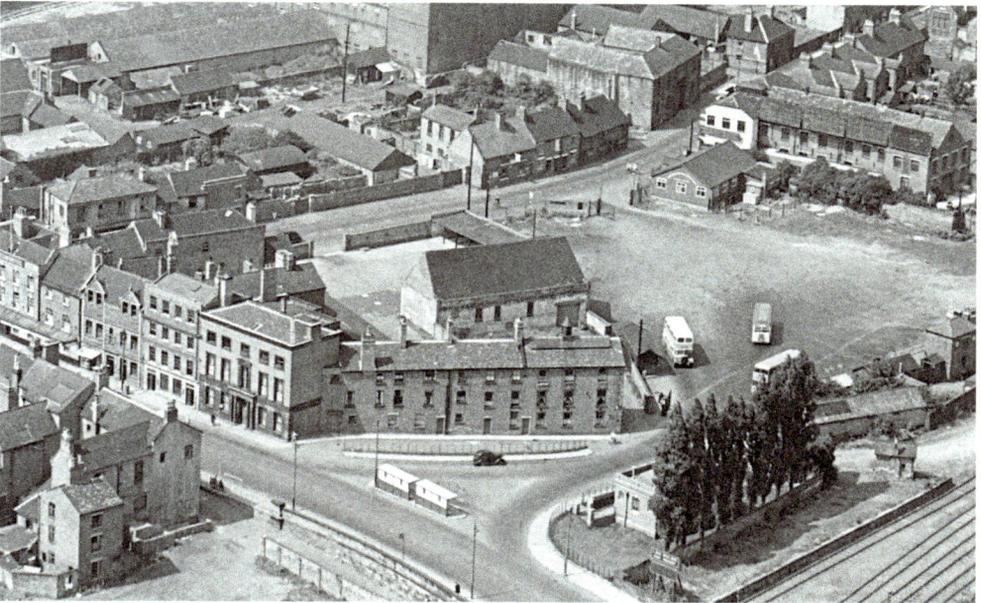

An aerial view of Bridge Street with the Printon/Musgrave brewery in middle of the picture (1947). (Author's Collection)

Where was Printon's Brewery? He was mentioned in the 1798 book *History of Staffordshire* by Stebbing Shaw, who noted that his business was established 'about ninety years ago … employing three men'. Printon's will sites his premises as 'in the Horninglow Street in Burton aforesaid near to the bridge end'. On a modern map, this would place the brewery before the crossroads with the High Street and Wetmore Road near to Spirit Games, because if you cross the High Street and head towards the bridge, Horninglow Street becomes Bridge Street.

Many streets and roads in Burton have changed their names over the years. Station Street was once Cat (or Catte) Street, Wetmore Road was Anderstaff Lane, Dover Road was Patch Lane and Bridge Street was no exception. *White's Directory of Staffordshire* 1834 lists five public houses on Bridge Street: Fox and Goose, Saracen's Head, Three Queens, the Ship and the Rose and Crown. In *Staffordshire General & Commercial Directory* of 1818, the first three are on Horninglow Street, while the Ship was at Bridge Foot and the Rose and Crown had probably not been built. Maps from 1679 and 1760 make no mention of Bridge Street, with it appearing instead as part of Horninglow Street. The 1760 map shows the plot that was the site of Musgrave's, and therefore Printon's Brewery. In modern terms, this is in the car park at the rear of the Three Queens Hotel. The 1947 aerial photograph (above) shows a now-demolished large white building with a high pitched roof, which is the most likely candidate for Printon's premises.

Other Early Common brewers

Horninglow Street became the early centre of brewing; along with Printon there was William Newton (the landlord of the Three Queens) around 1720 and Samuel

Clay House on the site of Joseph Clay's brewery, Horninglow Street. (Mac McCree Images)

Sketchley in 1740, Joseph Smith in 1710 on Horninglow Street and the Abbey Brewery on Abbey Street/Lichfield Street, which was owned by Daniel Watson (this was sold to Hill & Sherratt in 1740, who stayed there until 1872, when it was sold to Charrington's of London. Sports Direct now occupies the site).

Until this point Burton had a modest but successful industry. Although most of the ale was sold in the local area, the navigable River Trent allowed it to be sent to Hull and thereby London, and to a small extent overseas like the Baltic and Russia. Until around 1730, Derby was a more significant centre for brewing than Burton, but gradually brewers began to relocate, some from the Derby area like Henry Evans, Benjamin Wilson, Joseph Clay and John Davis Greaves, and those from further afield, like Samuel Sketchley from Nottingham. A number of factors were at play. The Haynes family had a tight control over the Trent Navigation, allowing Burton to become a hub for trade between Hull and Birmingham. Other industries in Derby such as silk became more important, and it also appeared that Burton water was much better suited for producing ale that would keep on long journeys. Between 1750 and 1775 ale exports from England to Russia rose from 740 to 11,205 barrels per annum; it is likely a high proportion was Burton Ale.

The 1740s also saw the first breweries appear on the High Street, including Benjamin Wilson at the Blue Stoops (directly opposite the old Burton Mail offices) in 1742, which later passed to his son, also Benjamin, and later to his nephew, Samuel Allsopp. The Blue Posts Brewery was opened in 1745, and The Crossing now occupies the site.

Further expansion was centred on Horninglow Street. Joseph Clay founded the Lamb & Flag Inn Brewery in 1751; two years later, Charles Leeson opened his brewery next door, Gervas Littlefere established the Vine Inn Brewery in around 1760, and John Thompson, in 1765, established the Bear Inn brewhouse.

These names, although playing their part in the early history, are overshadowed by two High Street concerns; both would endure in the town for over 200 years and would later merge in 1927 to form arguably the greatest brewery in the world. William Worthington, from Orton-on-the-Hill in Leicestershire, arrived in the town in 1744

Charles Leeson's brewery, Horninglow Street. (Mac McCree Images)

as a cooper for Joseph Smith, and his premises, established in 1760, occupied where Worthington Way and Burton Place now stand. William Bass founded his business on the High Street in 1777 and along with other notable figures such as Benjamin Wilson and Henry Evans, Bass and Worthington would make this quarter-mile stretch of road the birthplace of the Brewing Capital Of The World.

Views of Bass (Part One)

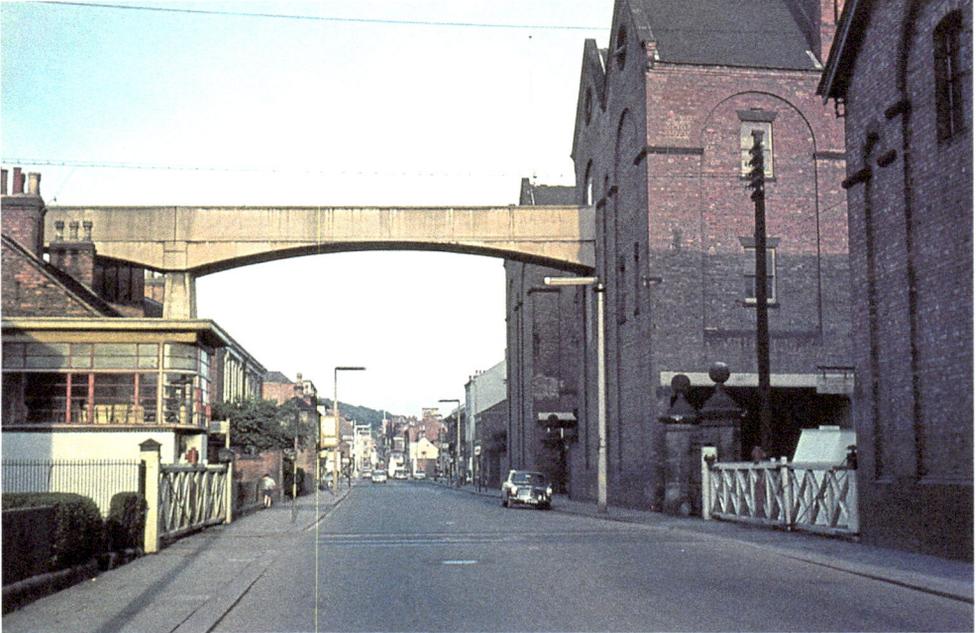

A view of Bass New Brewery with Delhi Maltings on the near right (21 June 1965). (Robin Jeffcoat)

The Bass New Brewery branch towards Middle Brewery (6 August 1965). (Robin Jeffcoat)

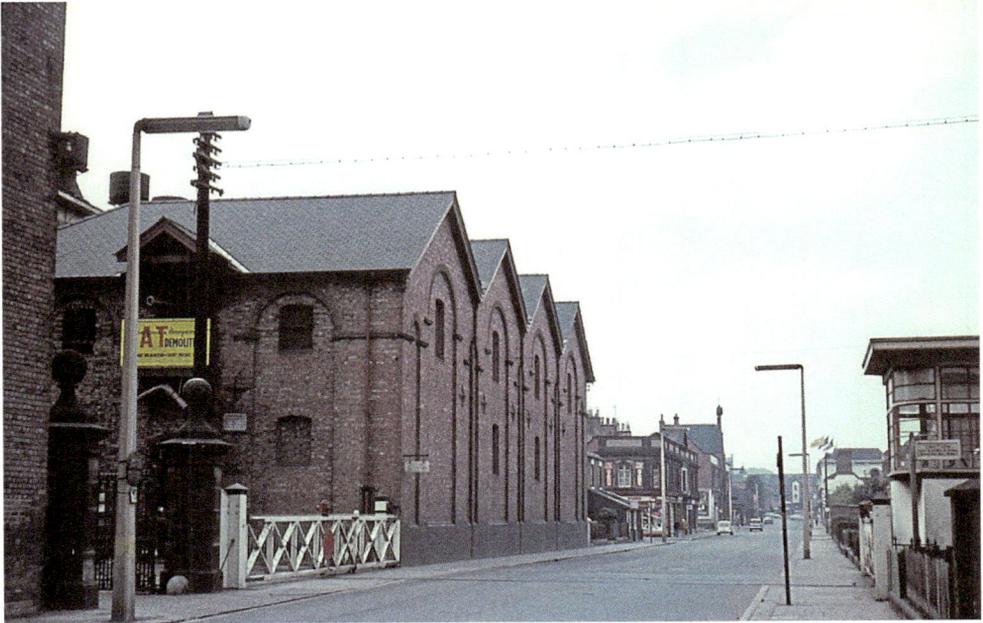

Bass New Brewery looking towards Station Bridge; note the Delhi Maltings (10 October 1965). (Robin Jeffcoat)

Looking in the opposite direction to the previous photograph (10 October 1965). (Robin Jeffcoat)

Bass New Brewery pictured from Station Street with Burton Hospital in the background (30 October 1965). (Robin Jeffcoat)

Bass New Brewery's Station Street crossing (10 October 1965). (Robin Jeffcoat)

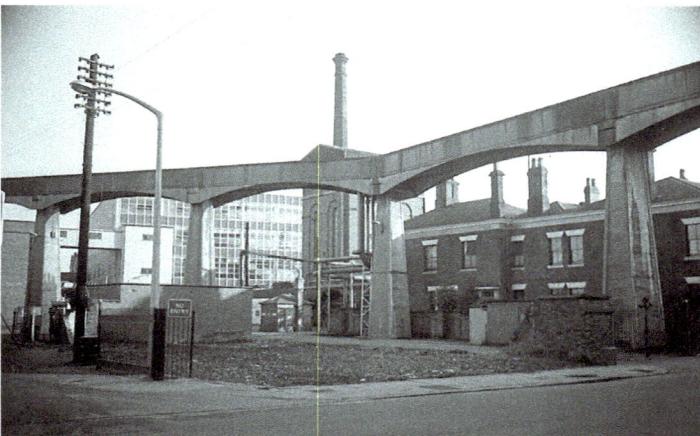

Bass New Brewery showing new development, with the cottages having been demolished (24 January 1971). (Robin Jeffcoat)

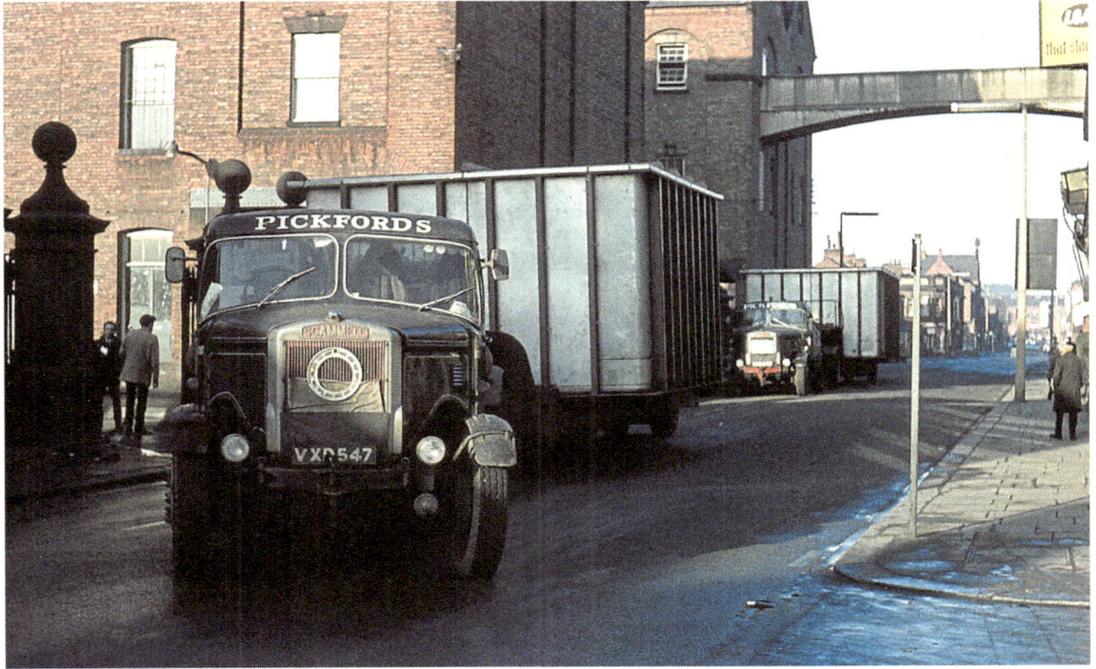

Two Pickford lorries seen delivering tanks for Bass New Brewery (8 February 1970). (Robin Jeffcoat)

Bass New Brewery from George Street (31 March 1986). (Robin Jeffcoat)

2

The First Expansion

Brewing in the late Eighteenth Century

The art of brewing in the late eighteenth century was a crude process and very little of the science was understood even by the established brewers. The brewing season was controlled by the weather and was restricted to the cooler months. Generally it ran from October to April, but this would be shortened by unseasonably warm conditions. Ale would vary in strength, colour and flavour from season to season and it was an ongoing struggle to produce a consistent product.

The secret to a successful brew was to use the best quality barley; this was sourced from farms in Nottinghamshire, Lincolnshire and East Anglia and would be malted locally. The better quality malt meant a higher yield of wort. Hops came from Kent via Southwark merchants or from Nottinghamshire, and of course the magic water Burton had in abundance. The final ingredient, yeast, was still a mystery; brewers knew that fermentation would occur when this was added to wort, but wouldn't have understood why.

Henry Allsopp's townhouse in Horninglow Street.

The Arrival of William Bass

It is likely that William Bass was born in Hinckley, Leicestershire, sometime between 1717 and 1720. Bass moved to Burton in the late 1750s with his wife Mary to run a carrying business that ran weekly between London and Manchester via Burton. This was lucrative and enabled Bass to invest in property in Burton. In 1777, in his late fifties, he purchased a large dwelling with brewing and malting facilities from Revd John Hepworth and Nathaniel Dawson for £1,050 on the east side of the High Street and quickly obtained the properties either side, which also had extensive brewing facilities. These three properties formed his first brewery, which was later to be known as Bass's Old Brewery, and would be a feature in the town for nearly 200 years.

William, along with his two sons, Michael Thomas and William Junior, learned the brewing trade from a William Yeomans; by the time of William Bass Senior's death a mere ten years later in 1787, the business was well established. In 1795 William Junior moved to the family estate in Ashbourne to run a carrier business, while Michael Thomas carried on the brewery, taking on John Ratcliff as a partner in 1796. The name 'Ratcliff' would remain in the company name until 1961. By the turn of the century, Bass and Ratcliff were brewing 2,000 barrels per annum – half for local consumption and the rest for Manchester, Birmingham and for export to the Baltic.

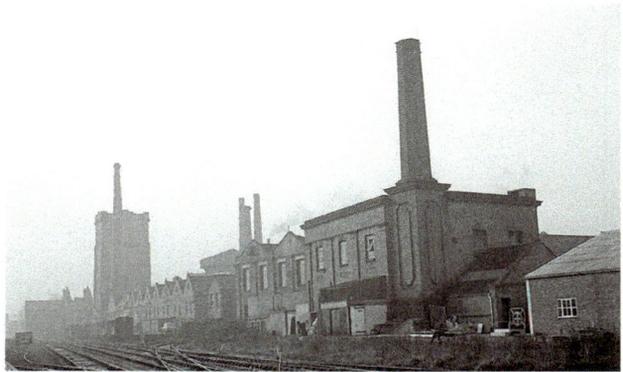

The Hay, showing Allsopp's Old Brewery in the foreground. Behind is Bass Old Brewery followed by Worthington's Maltings in the distance (30 December 1966). (Robin Jeffcoat)

Bass Plough Maltings, Horninglow Street. (Mac McCree Images)

Benjamin Wilson Senior

Benjamin Wilson Senior was the most successful Burton brewer of his time. Born around 1712, most likely in the Derby area, he moved to Burton in 1736 when he married Hannah Walker, the daughter of Mary and the late John Walker, who ran the Blue Stoops (an inn on the east side of the High Street). After Mary passed away in January 1742, Wilson bought the premises from his brother-in-law for £164. For this, he became owner of the inn and associated outhouses, stables and a brewhouse. Wilson had started life as a rope maker. This was a business that relied on Russian hemp, so he likely had contacts at Hull and understood the workings of the Trent Navigation. Within eight years he was employing thirty men and producing 1,000 barrels per annum, most of which were for export. Wilson Senior retired in 1773 and the business passed to his three sons, John Walker, William, and Benjamin Junior. It was Benjamin Junior who took the business forward, buying his brothers out.

By all accounts Benjamin Junior was a man wholly dedicated to brewing and was a bachelor who took little interest in public affairs. He extended the brewhouse in 1774, but was a man of caution; this was to pay dividends when the Baltic market suddenly collapsed in 1807. He purchased Samuel Sketchley's Horninglow Street Brewery in 1790 and two malthouses in Anderstaff Lane in 1800 from the late Charles Leeson.

Bass Maltings, Wetmore Road. (Mac McCree Images)

Henry Evans

If Benjamin Wilson Junior kept himself aloof from public matters, then Henry Evans was the opposite. He moved to Burton in 1754 after his father, Thomas Evans, a Derby merchant, bought a property on the High Street. Evans was not only a brewer, he was also a merchant, an ironmonger and a gentleman, which led to him being one of the richest men in the town. He owned Caldwell Hall along with 3,000 acres of land. Evans retired in 1795 and the business passed to his son, John Evans.

William Worthington

William Worthington paid £320 for Joseph Smith's Brewery in 1760, which was owned at the time by Richard Commings of Repton and run by Adam Bell. The premises were extended in 1761. Worthington conducted his business in a similar fashion to Wilson, using the same Hull merchants and ships. His output was around 1,500 barrels per year and by 1790 the company was trading as William Worthington & Sons.

Other Notable Brewers

John Musgrave acquired his brewery from Printon in 1729 and along with his son, William, they expanded the business, opening a second brewery in Horninglow Street (which was later sold to Samuel Sketchley in 1761). When William retired in 1779, the original brewery passed to his eldest son, Henry, who died young in 1781, and then his youngest son, James Wood Musgrave, who ran it in partnership with Bass. After Musgrave's death, John Davies Greaves took control but the business did not survive, eventually becoming part of Bass.

Charles Leeson bought his brewery in 1753 from William Newton. He purchased malthouses on the High Street and Anderstaff Lane, brewing mainly for the home market. He died a wealthy man in 1794, leaving not only his premises but £4,800. The brewery eventually passed to Joseph Clay Junior in 1801 and the malthouse to Benjamin Wilson.

The Lamb Inn was purchased by Joseph Clay Senior in 1751 and was on the south side of Horninglow Street, comprising a malthouse and a brewhouse. By 1790 he had a second brewery on the opposite side of the street and a cooperage on the High Street. Clay Senior died in 1800 and Joseph Clay Junior took over, buying Leeson's old brewery. Clay Junior and his son, Henry, became bankers, and eventually the running of the brewery fell to Thomas Salt, who had been in their employ as a maltster since 1774. Salt established his own brewery on the east side of the High Street next to Wilson in 1800, and the Clays later sold their brewery to him.

Opposite Clay's original brewery stood that of John Davies Greaves, the son of William Greaves. Purchased in 1774, it brewed mainly for export. By 1781 Greaves was a brewer and a cheese merchant; however, he was not a good businessman. After his death in 1784, there were several unsuccessful attempts to sell the business.

Much more successful was Samuel Sketchley. He was a merchant and had direct contacts in the Baltic. He exported ale and imported a wide range of goods, and his brewery became the second largest in the town. Following his death in 1775, his sons,

The view down High Street. (Mac McCree Images)

Samuel and Henry, took over the business; both would later move back to Newark and the brewery was sold to Wilson in 1790.

The southern end of the town also boasted breweries. Along with Hill and Sherratt on Abbey Street there was Thomas Morecroft, who operated between 1775 and 1795 on Lichfield Street, as well as Thomas Dicken, who leased the Angel Inn in the High Street.

Other brewers included John Gretton (later associated with Bass), Thomas Robinson (an employee of Worthington), as well as Thomas Hackett, William Kinder, Gervas Littlefere, John Thompson, John Walker Wilson, Thomas Dickens, Edward Coates and William Morris.

Views of Bass (Part Two)

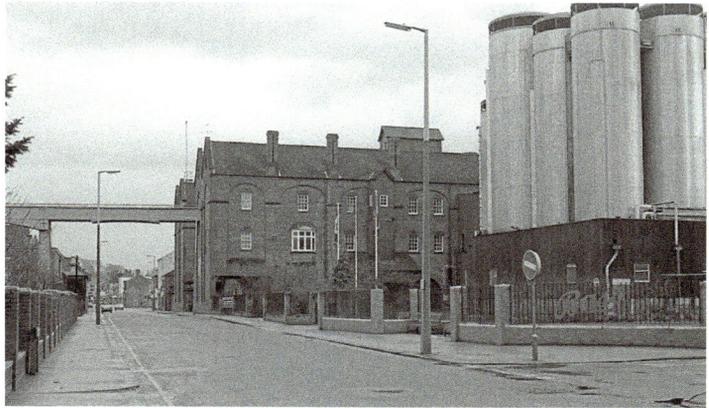

Bass New Brewery; note the new MPV tanks on the site of Delhi Maltings (31 March 1986). (Robin Jeffcoat)

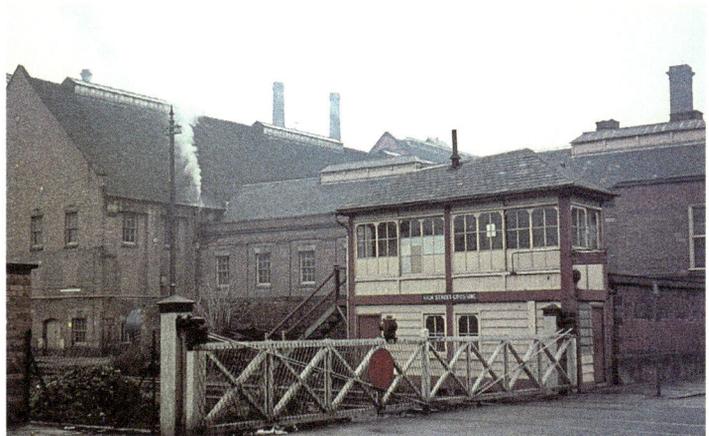

The High Street crossing of the Guild Street branch (23 January 1966). (Robin Jeffcoat)

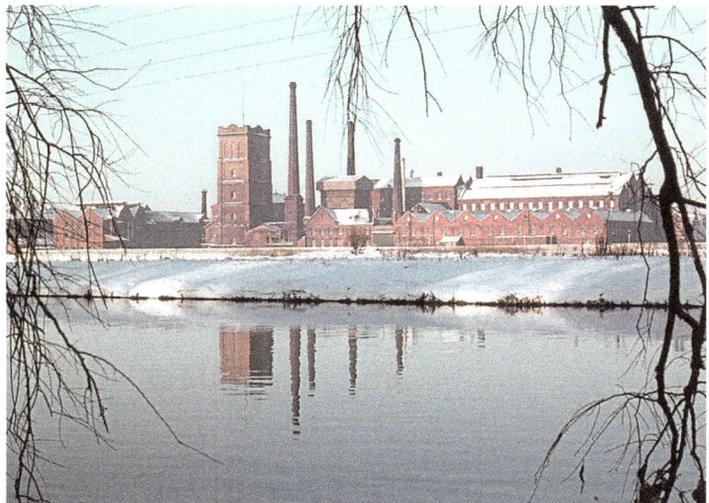

The Hay in the snow, seen from Stapenhill Gardens (8 February 1969). (Robin Jeffcoat)

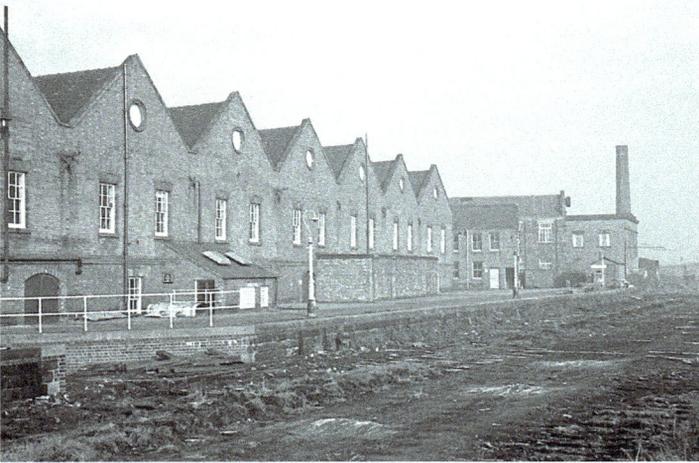

Bass Old Brewery's
ale-loading docks,
looking towards
Trent Bridge
(17 December 1967).
(Robin Jeffcoat)

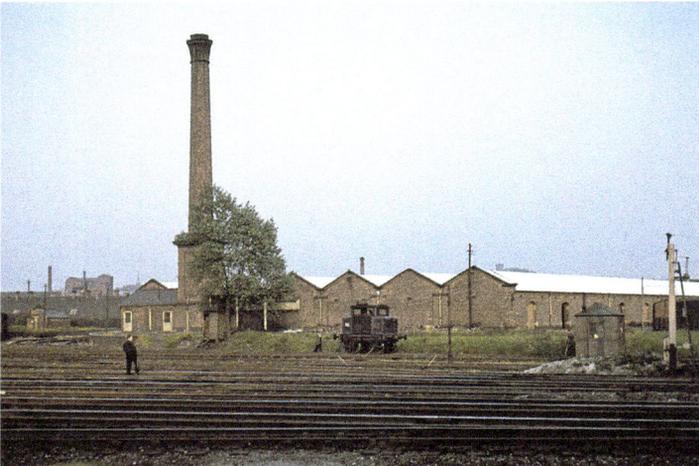

Bass' Guild Street
branch behind
the Dixie sidings
(27 May 1964).
(Robin Jeffcoat)

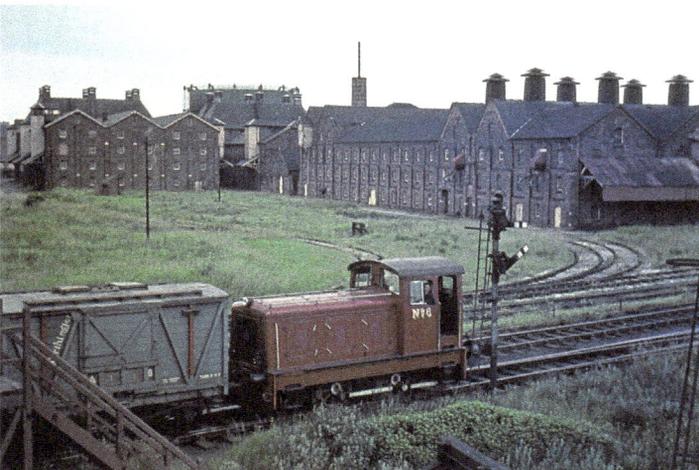

Bass' Hay branch
with Salt's Walsitch
Maltings in the
background (21 June
1965). (Robin
Jeffcoat)

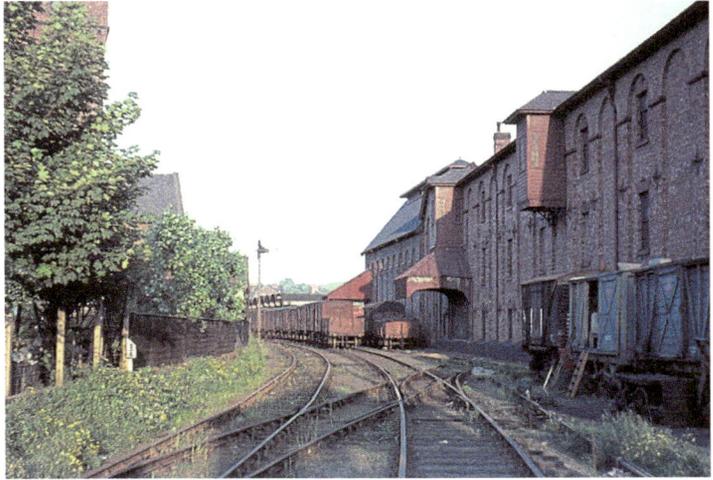

From Guild Street, this is the crossing towards Bass Middle Yard (27 June 1965). (Robin Jeffcoat)

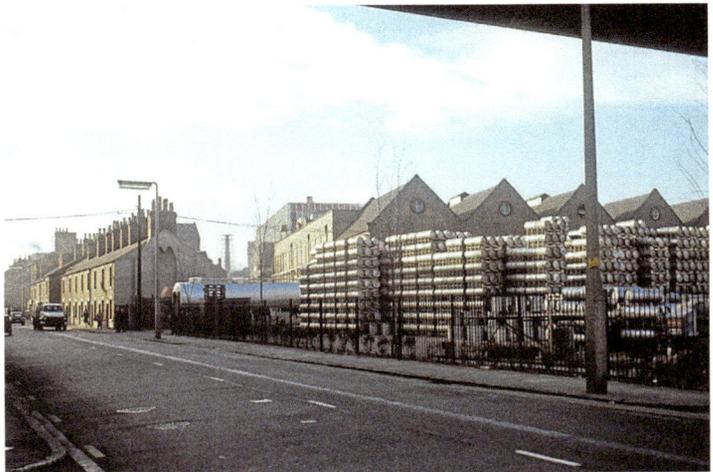

The Bass Middle Yard storeroom on Guild Street (23 December 1965). (Robin Jeffcoat)

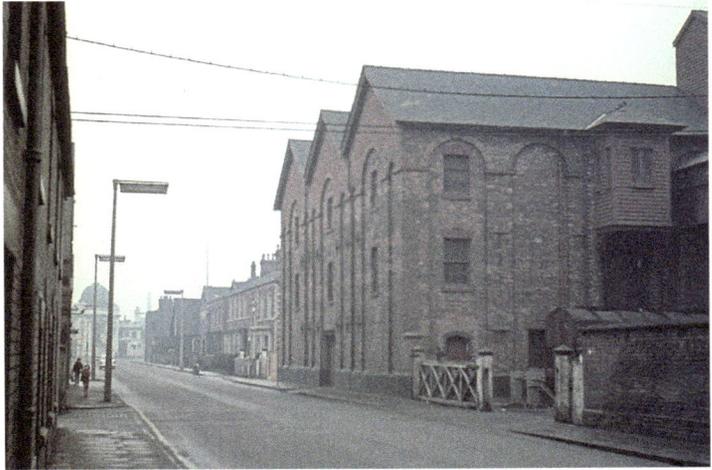

A view of Guild Street with stacks of Bass kegs (28 December 1971). (Robin Jeffcoat)

3

As One Door Closes...

The Collapse of the Baltic Trade

By 1780 there were thirteen breweries. Out of these only one produced more than 2,000 barrels per annum, and the total output of the town was about 20,000, of which 8,000 went for export; compare this to London, where the six major breweries were producing 60,000 barrels each!

In 1792 Russia invaded Poland. This reduced the Baltic trade and required Burton brewers to seek out other markets. As a result, beer was sent to London, Liverpool and other major English towns. Many diversified and traded in other commodities such as wheat and timber, becoming merchant brewers rather than common brewers. This was not a new idea; timber, especially Russian and Polish Memmel oak, which was perfectly suited for making barrels, had long been taken in part-exchange for ale. Merchant brewers profited almost as much in the import of flax, hemp, timber and iron as they had in the export of ale. This economic pressure forced smaller breweries into bankruptcy or to amalgamate with the larger concerns. From a peak of fifteen breweries between 1777 and 1790, only eleven remained in 1807.

1807 was a watershed year in the town's history. The Napoleonic Blockade abruptly ended the Baltic trade almost overnight, and this signified the end of the Burton merchant

The fate of breweries from 1800 to 1806

Year	Brewery	Fate
1800	Charles Leeson	Sold to Joseph Clay
c. 1800	Thomas Dickens	Ceased brewing
1803	John Musgrave	Sold to John Greaves
1805	John Greaves	Sold to Bass
1806	Edward Coates	Bankrupt
1806	Benjamin Wilson (Junior)	Sold to Samuel Allsopp

brewer. Brewing in Burton was to radically change again, as it had done 100 years before, now seeing the rise of brewers who concentrated solely on the production of ale.

The twenty-four-year period from 1803 to 1827 saw only one new brewery founded; that of John Greaves. He was to go bankrupt a mere two years later, selling to Bass. Trading conditions were very hard for the Burton brewers.

After selling his brewery to his nephew Samuel Allsopp in 1806, Wilson retained an interest in the business and they traded as Wilson-Allsopp. From pre-blockade figures of 3,400 barrels per annum, 2,600 of which were exported, this dropped to 1,000 with nothing being exported. If Wilson-Allsopp can be considered typical, brewers saw their business cut by 70 per cent.

Allsopp was convinced that the blockade would soon end and continued to export small amounts. This was risky and expensive due to the insurance costs and often the ale didn't reach its destination. Other markets were sought; the obvious choice being London, where Burton ale had long been held in esteem. However, due to high freight charges, Burton ale was more expensive than the local beer. Due to the export nature of Burton's breweries, the idea of the tied house (a pub owned by a brewery that would only sell their ale) was almost unheard of. Brewers, therefore, found themselves at the mercy of merchants, so Allsopp and the other Burton brewers cleverly entered into a price-fixing agreement.

Allsopp adapted his business, brewing beer to suit local tastes and even produced porter for the first time. Attempts at other markets were met with limited success. Rather than dealing with thirty Baltic merchants, he found himself with ninety countrywide, which increased the amount of administration. Thefts were not unusual, especially on the canals.

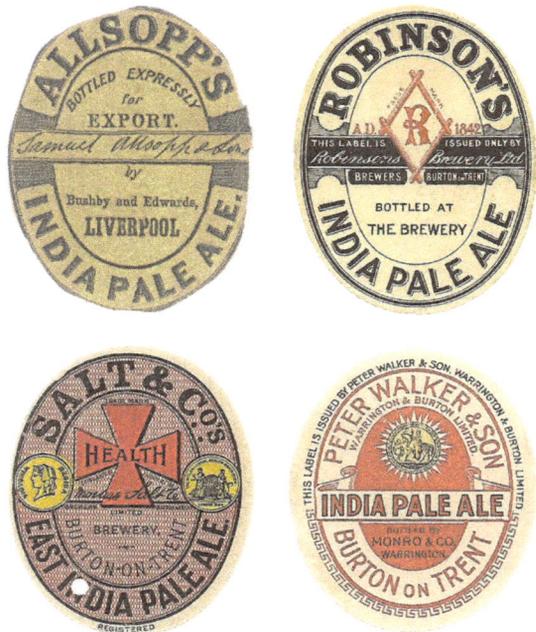

Various India Pale Ale labels
(*c.* 1840s to 1890s). (Keith
Osborne / National Brewery Centre)

Through hard work Allsopp was able to establish a relatively successful inland trade, but nothing like pre-1807. The war ended in 1815 and the Baltic trade revived; there was even trade with Russia between 1820 and 1822. However, due to Baltic breweries that had been established during the years of the blockade, a high tariff on English ale and a decline in the import requirements of some Baltic products, the trade was ended for good. This could have signified the end of the expansion of Burton upon Trent's brewing industry had it not been for two London brewers.

India Pale Ale

Founded in 1600, the East India Company grew in influence throughout the seventeenth and eighteenth centuries, making a lot of people very rich. Goods from India were shipped back to England including perfumes, spices and cloth, and on the journey out there was beer; initially porter, by 1784 it was ale. George Hodgson's ale was first mentioned in 1801. He founded his small brewery some fifty years before in Bow, a short barge ride from the East India Company's docks at Blackwall. This and his arrangement of giving captains up to eighteen months' credit meant that they were happy to buy from him. Fast forward to 1821 and the business was being run by Frederic Hodgson and Thomas Drane, who supplied the majority of pale ale being sold in India.

Hodgson and Drane had a plan to remove the East India Company from the equation and set themselves up as shippers. That way they could corner the market and make even more money by selling the ale once it arrived in India. They put their prices up by 20 per cent and dealt only in cash. The East India Company were furious and their merchants in India instantly lost a lot of business. When they tried to source ale from elsewhere, Hodgson and Drane simply undercut them, pricing them out of the market.

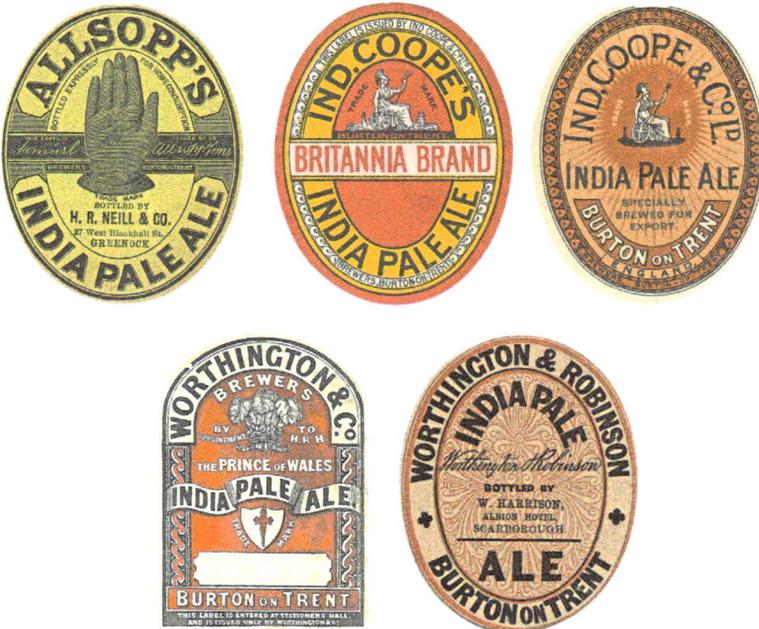

More India Pale Ale labels (*c.* 1860s to 1890s). (Keith Osborne)

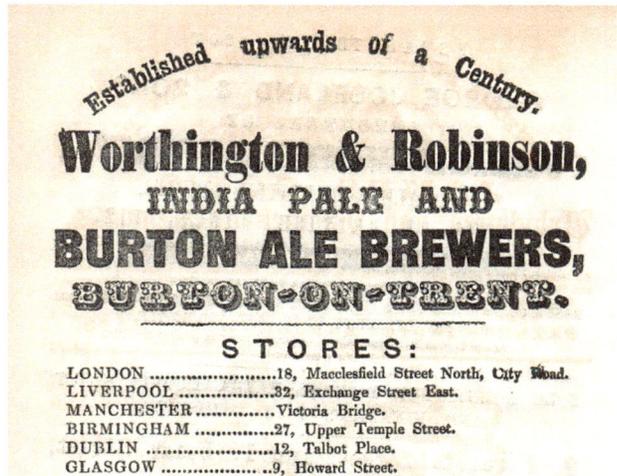

Established upwards of a Century.

Worthington & Robinson,
INDIA PALE AND
BURTON ALE BREWERS,
BURTON-ON-TRENT.

S T O R E S :
LONDON18, Macclesfield Street North, City Road.
LIVERPOOL32, Exchange Street East.
MANCHESTERVictoria Bridge.
BIRMINGHAM27, Upper Temple Street.
DUBLIN12, Talbot Place.
GLASGOW9, Howard Street.

Advert for Worthington & Robinson (1862). (Gary Summerfield Collection)

The tale goes that Samuel Allsopp was invited to dine in London in 1822 with Mr Campbell Marjoribanks (pronounced Marchbanks), an East India Company director, at his house on Upper Wimpole Street in London. After dinner the talk got around to ale and the significant trade to India, of which Allsopp claimed to know nothing about. He was presented with a bottle of pale ale that had been brewed in London by Hodgson and exported to India. When tasting it Allsopp exclaimed, 'Is this the Indian beer? I can brew it.' Marjoribanks replied, 'If you can, it will be a fortune to you.'

When Allsopp returned home, samples of the ale were sent to him and the brew was replicated by Allsopp and maltster Job Goodhead in a teapot. It was this that truly started the growth of Burton.

Now whether the story is true or just apocryphal is up for debate. Certainly Allsopp having never heard of the Indian market seems unlikely, and he'd also tried his hand at pale ale in 1809 when experimenting for the home market, but it is a good story!

Allsopp first exported his India Pale Ale in 1822, sending forty-five barrels. This soon began to command a higher price than Hodgson's. By 1824 Allsopp sent 2,000 barrels, almost replacing the lost Baltic trade, and Bass and Salt followed suit in 1823. By the 1830s Bass and Allsopp together were exporting 6,000 barrels per annum to Calcutta (and it is likely more was sent to other ports), with Bass having the lion's share (although it is likely he was exporting ale from Salt, Worthington and other Burton brewers). The quality of Burton water yielded a product that was vastly superior to that brewed with London water and led to Burton's dominance in the market during the next few decades.

One story claims that a boat was shipwrecked in the Irish Sea with the barrels ending up in Liverpool, thus starting a home market for India Pale Ale, although this is disputed by some historians.

The Road to Recovery

In 1822 only five breweries remained: Samuel Allsopp & Co., Bass & Ratcliff, Thomas Salt & Co., William Worthington and John Sherratt. Allsopp and Bass were the most important, the latter having the upper hand due to having developed the home market

to a greater extent. Bass bought additional land on the High Street and expanded his premises. When Michael Thomas Bass died in 1830, the firm was producing 10,000 barrels per annum, over half of which were intended for export.

After 1830 Bass was run by five men: Michael Thomas Bass II and Samuel Ratcliff (the sons of Michael Thomas Bass and John Ratcliff), John Gretton, Charles Walter Lyon, and Joseph S. Clay. In comparison, Allsopp's remained under the management of Samuel until his death in 1838, after which it was run by his son, Henry Allsopp. It was around this time that Allsopp's output fell below that of Bass.

Thomas Salt had bought up the old breweries of Clay, Leeson, Musgrave and Greaves. Another brewery was founded in 1792 on Patch Lane (later Dover Road) by Edward Coates, and this would later fall into the hands of John Marston, the sole remaining brewer (in name at least) in the town today.

Along with the existing breweries, fifteen new concerns were founded between 1828 and 1850 – an unprecedented rate of expansion. John Greaves' Brewery, which had been standing empty since 1805, found a buyer in 1828 in Mason & Gilbertson. The new businesses were as follows: Charles Hill in Lichfield Street and Brunt & Bucknall at Woodville (both 1832); John Marston at Patch Lane (1834); Philip Tyzack and Jonathan Meakin (both on High Street on 1834); William & Thomas Saunders (1835) on Horninglow Street; Bridge Street Brewery (in around 1835); Burton Brewery Co. (1842) on High Street (next to Salt's); Peaks & Riddell (1842 on Horninglow Street); Benjamin Hicklin and Sarah Measom (both on the High Street in 1845); William Middleton on High Street in 1846 (Middleton would later play a part in the Ind Coope story); and finally Joseph Bowler on New Street and Wyllie Bros on High Street (1851).

Advert for the Burton Brewery Co. Ltd (1862). (Gary Summerfield Collection)

Not all of these businesses would last; in fact, many of them were small concerns run in a similar fashion to the common brewers a century before. Only three of these would still be trading as the twentieth century arrived – Brunt & Bucknall, Burton Brewery Co. and, of course, John Marston.

The son of Edward Marston, John Marston, who had unsuccessfully run a brewery attached to The Cock Inn at Uttoxeter, moved to Burton. By 1818 he had a business in Anderstaff Lane as a grocer and tea dealer; he also dealt in skin, horsehair and rags. By 1823 he had taken over the site of Coates' old brewery on the Patch Lane/Horninglow Road North corner, which had been empty since Coates went bankrupt in 1806, firstly as a maltster and then in 1834 as a brewer.

By 1840 Burton had a healthy brewing industry, employing 350 men and producing an annual output of 60–70,000 barrels, of which Bass, Ratcliff & Gretton and Allsopp were responsible for 15–20,000 barrels each.

The arrival of the railway in August 1839 would change the face of the town forever. Until then, Burton brewers were at a disadvantage; they were able to produce the best beer in the world but had limited ways of transporting it. London brewers were already enjoying the benefits of a railway system from the mid-1830s, enabling quick and cheap transport. Beer that used to take a week to arrive in London via canal at 60s per ton now took a mere twelve hours at a quarter of the cost.

Samuel Allsopp (who died the year before the railway opened), William Worthington, Thomas Webb and Michael Thomas Bass II were heavily involved in the railway project. The Birmingham & Derby Junction Railway directly linked Burton with the ports of London and Liverpool, and from there the rest of the world.

The railway passed Burton to the North West, almost parallel to the Moor Mill Dam. At first traffic was light, being discouraged by high costs; then the Midland Counties Railway opened in 1840 and the competition reduced freight costs. The Birmingham & Derby Junction Railway, Midland Counties Railway and North Midland Railway amalgamated in July 1843 and by 1 July 1844 the Midland Railway began operating.

Ale was loaded onto horse-drawn carts and floaters and was taken to the station situated on the now-renamed Station Street. Congestion quickly became a problem, with the streets being crowded from morning until night. Railway Acts were passed, allowing the building of the Hay branch, Guild Street branch and a new Burton Bridge (locally known as the Trent Bridge), which eased the problem.

As the 1840s moved into the 1850s, the annual barrelage rose to 300,000 and the manpower increased to just shy of 1,000. The two main firms, Bass and Allsopp, had reinvested profits; extending their premises and making use of steam-powered machinery. This, in turn, increased efficiency.

Until 1840, Bass limited expansion to their original premises on the east side of High Street. In 1842 they purchased property from Worthington on the other side of High Street, which would become Bass Middle Yard. Malthouses were acquired from John Mason on Anderstaff Lane three years later. Additions were still made to the original premises, including the building of the water tower in 1856, which still stands today, next to the library.

Views of Bass (Part Three)

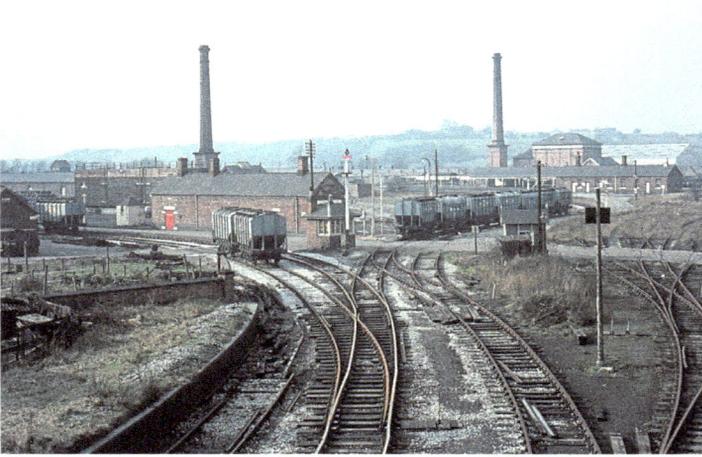

Bass' Shobnall branch. The site is currently occupied by the roundabout near Burger King (15 February 1968). (Robin Jeffcoat)

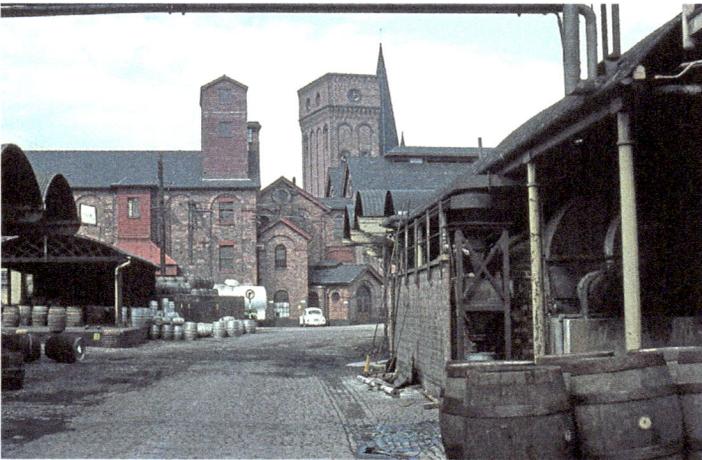

Bass' Electric Cooperage on Station Street (28 June 1970). (Robin Jeffcoat)

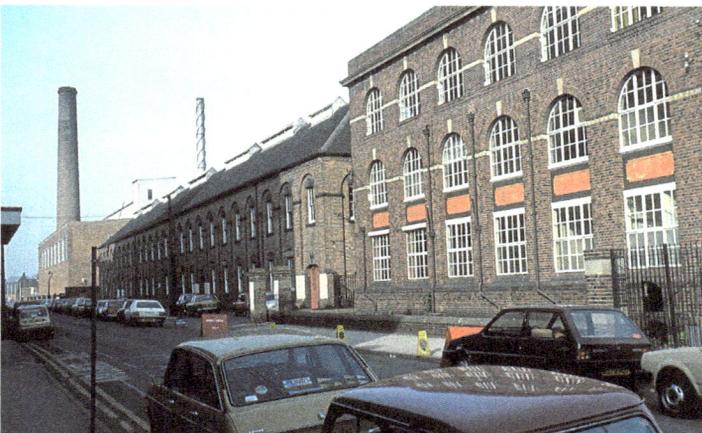

Bass New Brewery's laboratory on Duke Street (28 October 1985). (Robin Jeffcoat)

Views of Worthington

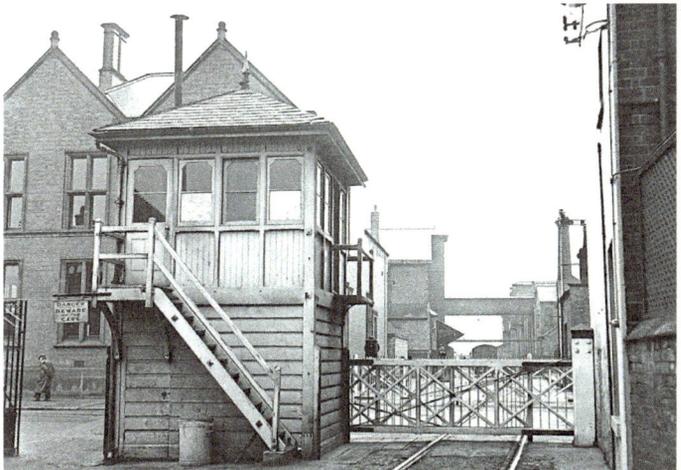

The High Street crossing at the Worthington branch; note the original Blue Posts (1910). (Courtesy of Philip Stanbridge)

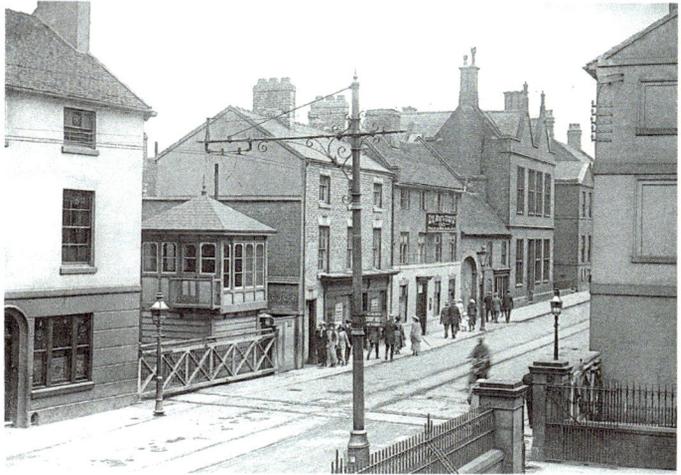

A similar view to the previous photograph; note the actual blue posts and large Worthington sign (19 September 1967). (Robin Jeffcoat)

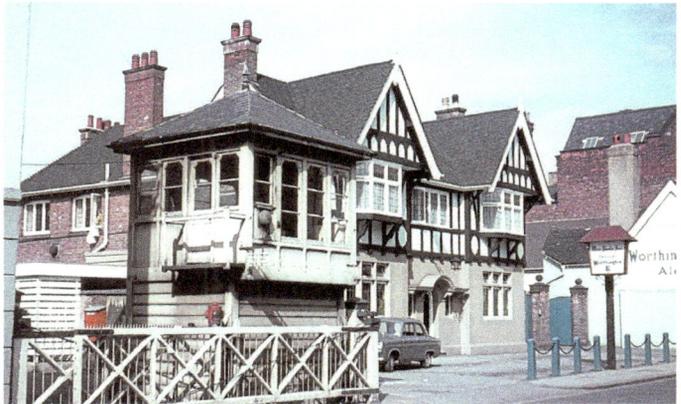

Worthington's signal box, looking across High Street to Hay (c. 1940s). (Courtesy of Philip Stanbridge)

The site of the Worthington branch, looking towards High Street. The platform was an old loading dock (28 June 1970). (Robin Jeffcoat)

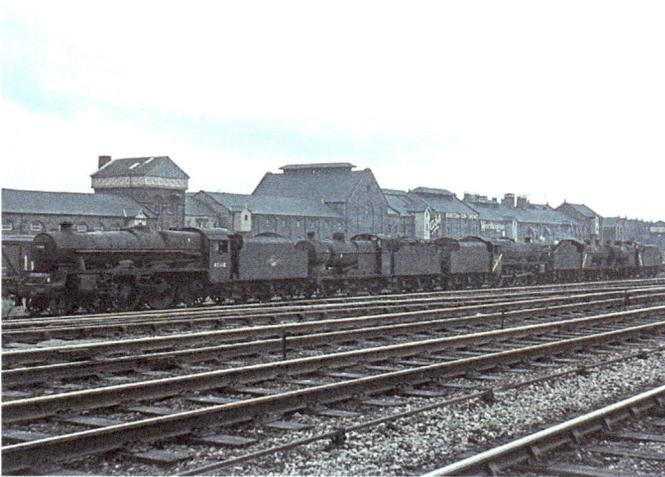

The Worthington Crown Maltings (originally Meakin's), seen from Moor Street Bridge (16 September 1964). (Robin Jeffcoat)

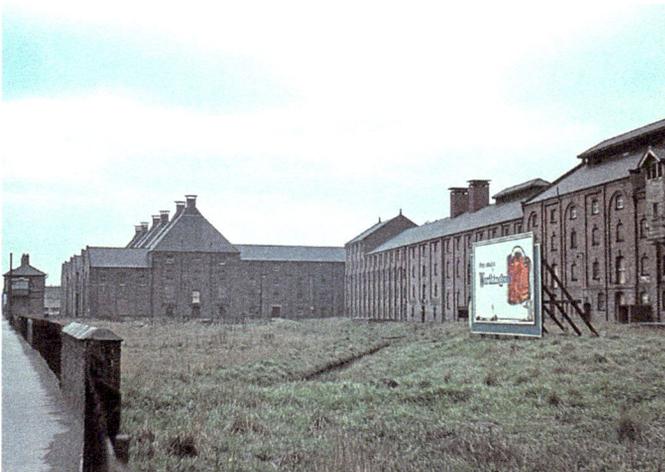

The Worthington Crown Maltings, seen from Anglesey Road (3 April 1966). (Robin Jeffcoat)

Worthington's Maltings, seen from the Hay (28 July 1968). (Robin Jeffcoat)

Worthington's ale store and maltings, seen from St Modwen's Garden (28 December 1971). (Robin Jeffcoat)

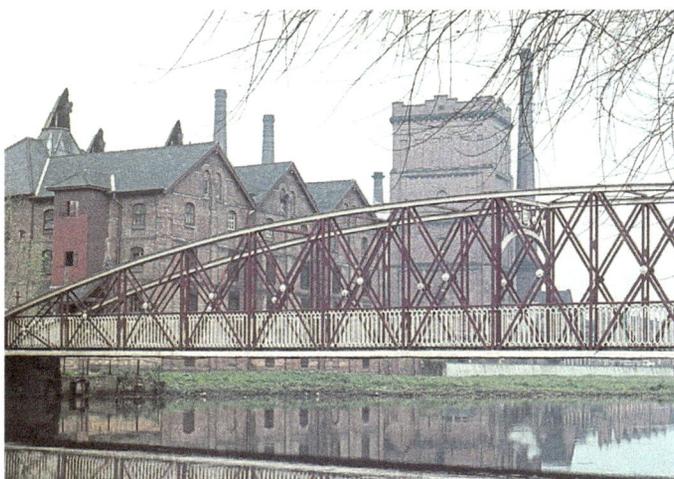

Worthington's Maltings and Bass' water tower, including the Andressey Bridge (4 November 1968). (Robin Jeffcoat)

4

The Brewing Capital of the World

The forty-year period between 1850 and 1890 saw Burton reach its zenith. In 1851 the London breweries still dominated the country, but by 1888 Burton was producing twice the amount as the capital.

Reinvestment saw the introduction of laboratories and qualified chemists, allowing for greater understanding and therefore control of the brewing process. Firms began to employ engineers to look after the increasingly mechanised processes, which included rudimentary bottling machines for the first time.

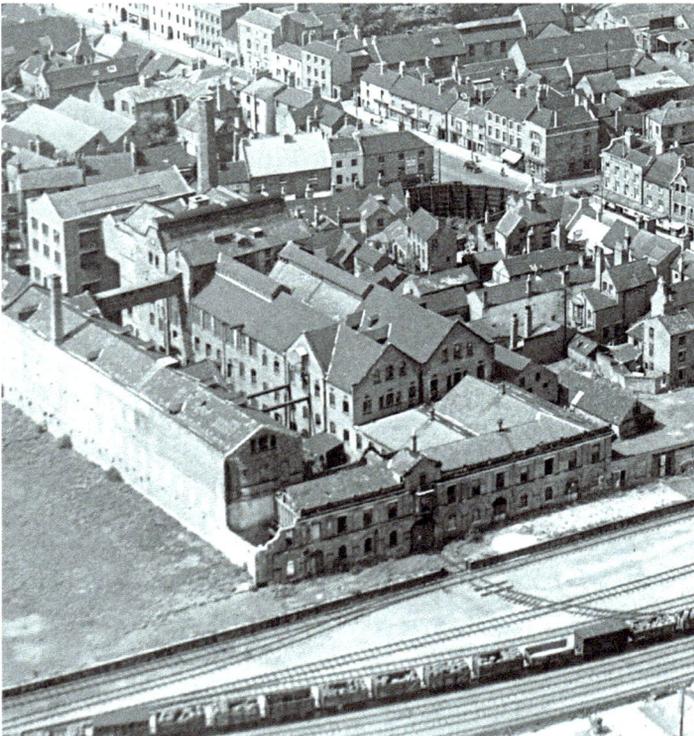

An aerial view of Burton Brewery Co. Ltd (later Worthington's), High Street (1947). (Author's Collection)

The smaller firms struggled with raising the necessary capital to fund this expansion and many went bankrupt, ceased production or were taken over by the bigger concerns. In 1872 and 1884 there were a record thirty-four breweries; by the dawn of the twentieth century this had dropped to twenty-four. One of the casualties was the Blue Posts Brewery, which was bought by Marston's in 1890 after 145 years of trading.

Other casualties included: William & Thomas Saunders, who sold to Bass and the Burton Brewery Co. in 1865; Bridge Street Brewery was sold to Burton Brewery Co. in 1896; Perks & Riddell was sold to T. M. Carter in 1862, who later sold it to John Thompson in 1867; and Joseph Bowler was bought by Marston's in 1891. The Coach and Horses Brewery was sold to Salt in 1864; the Carpenters Arms Brewery was sold to Bindley in 1874; and Clements & Berry sold to Dobson & Co. in 1876, who lasted three years before selling to Worthington.

Attracted by the water, out-of-town brewers began to invest in Burton. Ind Coope & Co. from Romford bought William Middleton's partially erected brewery on Station Street in 1856, while Henry Boddington from Manchester arrived in 1869 and Charrington & Co. (established in 1757 at Mile End in London) bought the Abbey Brewery. In 1873, Truman, Hanbury & Buxton acquired the Black Eagle Brewery on Derby Street, which had been built for Philip Bros. The Albion Brewery on Shobnall Street was built for Mann, Crossman & Paulin from the East End of London in 1874; this was sold to Marston's in 1898 (John Thompson amalgamated with Marston's in the same year). Two brothers from Warrington, Andrew Barclay Walker and Peter Walker, moved to the Shobnall Brewery in 1877 and the Clarence Street Brewery in 1882 respectively, and Everard & Co. from Leicester leased Henry Boddington's Brewery on Meadow Road, Trent Bridge, in 1892 (later moving to the Trent Brewery on Anglesey Road in 1903).

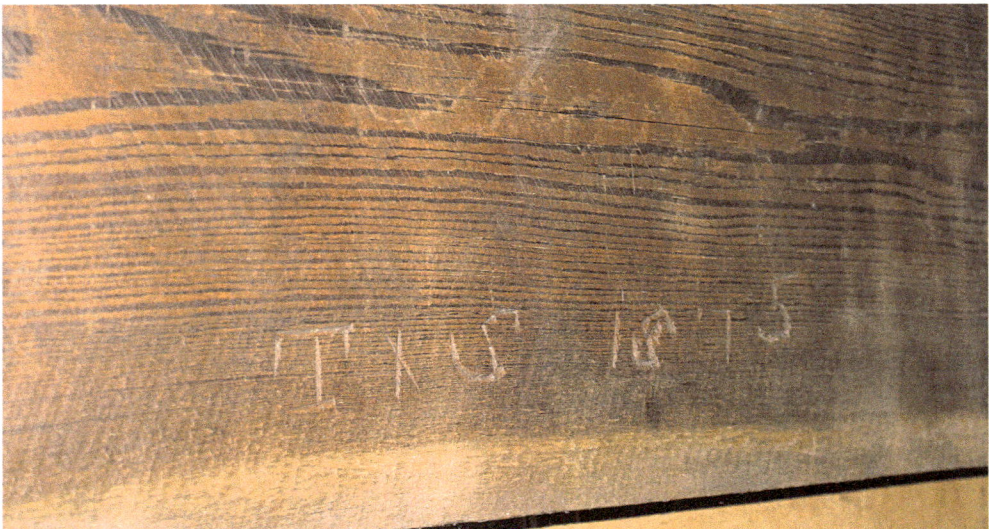

Engraving 'T.S. 1875' (Thomas Salt 1875) on a roof beam at Walsitch water tower (now Tower Brewery).

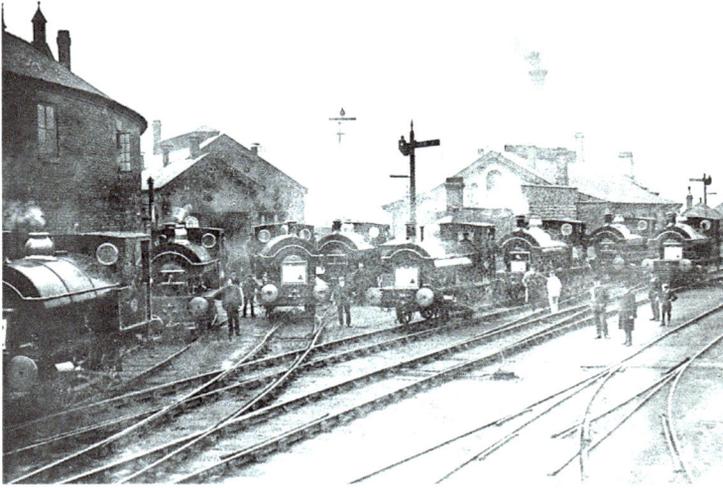

Bass locomotives at Guild Street engine shed (c. 1900). (Courtesy of Philip Stanbridge)

There was also a high turnover of other short-lived businesses; Benjamin Hickin ceased brewing as did Sarah Measom. Wylie Bros lasted a mere six years, from 1850 to 1856, while John Youill was bankrupt in 1856 after two years. Edwin Atkin lasted ten years, Joseph Thompson fifteen years and Charles Cooper lasted eight years. William Appleby brewed at the Devonshire Arms for thirteen years; meanwhile, Dickenson & Co. lasted six years, Thomas Gaunt nine years and Clayton & Co. traded for twelve years at the Trent Brewery (later used by Everards). Popplewell and Dawson & Co. lasted three years, as did Arthur Scattergood, Thomas & Thomas William Thompson and Broadway Brewery. William Henry Ball lasted two years. Thomas Sykes went bankrupt in 1896 while John Booth, Charles Hill and Porritt, Norman & Co. went bankrupt in 1884, after just two years of trading.

The Second Expansion

Throughout the second half of the nineteenth century, two Burton brewers were dominant: Bass, Ratcliff & Gretton and Samuel Allsopp & Sons. By skilfully reinvesting profits into new steam technology, processes that once required substantial manpower became more automated. London brewers had embraced steam power before 1800, but the use of men and horses were still popular in Burton even into the 1820s.

In 1851 Allsopp's output was 80,000 barrels; ten years later it was 270,000! In 1857, land at Moor Mill Dam near the railway station was purchased and here Allsopp's New Brewery was built for £27,000. By 1875 the company reached its peak output of 700,000 barrels. From then on it rarely ran at full capacity, managing around 500,000 barrels; this despite the introduction of summer brewing in the 1880s.

Unlike the London brewers, who had long understood the need for a tied estate to sell their ale, Burton's brewers, who had traditionally relied on the export market, left this side of the business underdeveloped. Bass had sensibly adopted the policy of buying tied houses from 1860, but Allsopp did not (*see 'The Allsopp Fiasco' on page 42*).

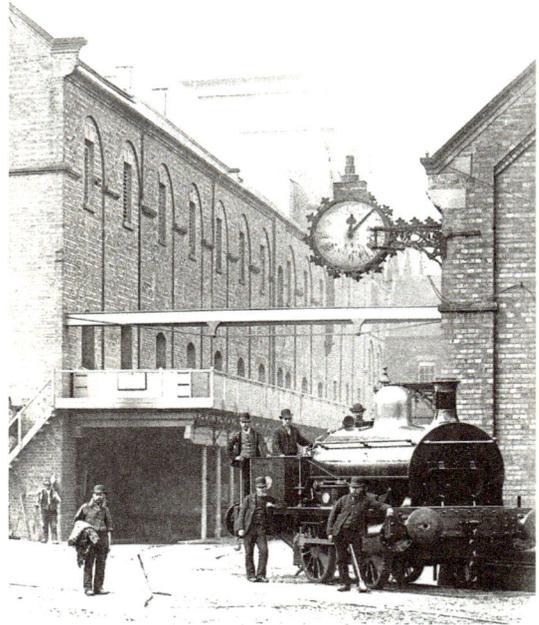

Bass locomotive (pre-1900).
(Courtesy of Philip Stanbridge)

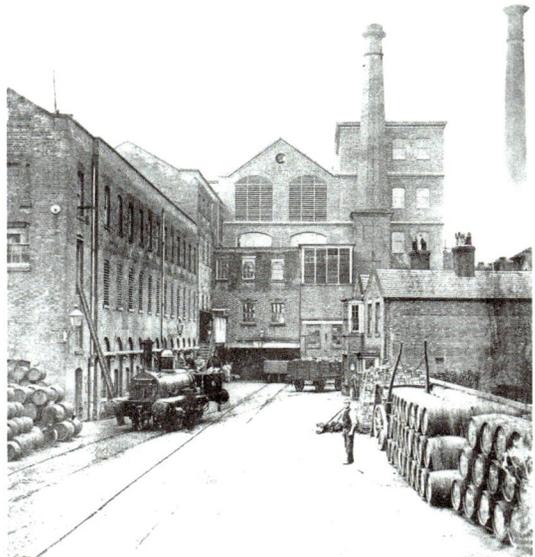

The first Ind Coope locomotive,
Jenny Lind (1894). (Courtesy of
Philip Stanbridge)

On 1 January 1876, Bass made history by registering their Red Triangle as the country's first ever trademark, with their Red Diamond as trademark number two. An employee spent New Year's Eve 1875 camped outside the Registration Office to ensure this happened. One of the most famous trademarks in the world, the Red Triangle can even be seen in Manet's painting *Un bar aux Folies-Bergère*.

As land became scarce in the centre of the town, the second phase of development was centred on Victoria Crescent between 1865 and 1875. Four new breweries, Clayton & Co., Ball & Co., F. Heap and T. Cooper & Co., had been established by 1875. The third phase was at Shobnall between 1874 and 1880, which saw not only the breweries of Mann, Crossman & Paulin and A. B. Walker, but also extensive maltings for Bass and Allsopp. Burton became a town dominated by one industry, and among the massive brewery buildings and towering piles of casks ran the extensive railway lines and sidings.

Local labour became hard to come by, and so the Norkie was born and seasonal labour for malting in Burton was sourced from East Anglia. There was a link between Burton and the barley-growing areas of Suffolk and Norfolk, and the growing and malting seasons were complimentary, meaning that a worker could obtain year-round employment. Generally the successful Norkie would arrive in Burton mid-September and leave in May. Applicants needed to be fit and strong, and those found to be hard working and of a sober nature would be invited back year after year. After a successful interview they were given a free train ticket and would be lodged near to the malthouses in places like Grange Street, Wellington Street, Anderstaff Lane, Cross Street and Victoria Crescent. Bass were the principal employers, although other brewers were likely involved. By the mid-1890s around 3,000 to 4,000 Norkies (a misleading term as the majority came from Suffolk) were employed. As time went on many settled in the town and the system ended at the outbreak of the Second World War.

How Big was Burton?

In 1869 the town boasted thirty breweries, over 100 malthouses, nearly eighty ale stores and approximately twenty cooperages. Eight private locomotives ran on 18.5 miles of private railways, and there were also sixty-seven steam engines. The years 1872 and 1884 saw thirty-four breweries in operation.

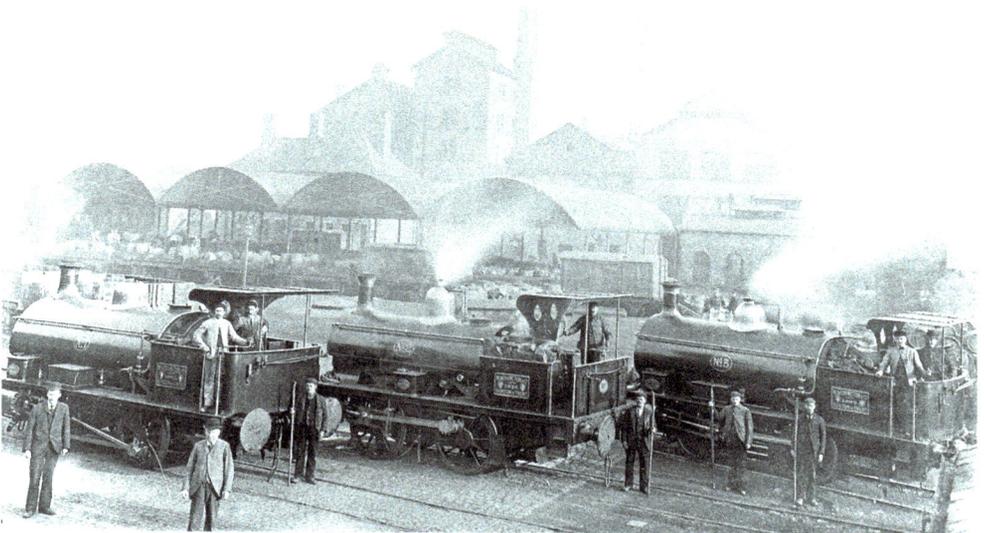

Worthington's brewery (*c.* 1900). (Courtesy of Philip Stanbridge)

In 1888, when legendary brewery historian Alfred Barnard visited the town, 8,215 people were employed, producing three million barrels per annum.

The top ten brewers were (in order): Bass, Ratcliff & Gretton Ltd, S. Allsopp & Sons Ltd, Worthington & Co. Ltd, Ind Coope & Co. Ltd, T. F. Salt & Co. Ltd, Mann, Crossman & Paulin, Burton Brewery Co., Truman, Hanbury & Buxton, Charrington & Co., and P. Walker & T. Cooper Co.

Interestingly, of these ten, five had been established after 1850.

The Growth of Marston's

By the time of his death in 1846, John Marston had built his business up and owned property in Burton, Uttoxeter, Derby, Overseal and Hartshorne. The running of the brewery passed to his three sons, John Hackett, William and Henry Marston. Although John Hackett Marston was his second son, he attained a position of seniority in the business and it was he who became 'good old John Marston, a great Victorian bloke', being made famous in the 1995 television advertising campaign.

Marston's was a small concern compared to the giants of Bass and Allsopp; in 1861, with ten men in his employ, he produced about 3,000 barrels. William left Burton in 1861 and Henry died young in 1865, so the brewery belonged solely to John.

Although the business had expanded four times at the Horninglow site, he needed partners to inject capital. William Wayte joined in 1878 and Richard Eddie in 1879. Also that year, the famous three barrels trademark was registered, which is still in use today. When John Hackett Marston retired to Hilton Lodge, Derbyshire, he sold the business to Henry Emmanuel Sugden, who also owned Nunneley's brewery, thus ending the Marston family connection forever.

Sugden made further purchases; namely, Yeomans' Blue Posts Inn and brewery and the Anchor Inn and brewery in 1890. In 1898 there was a merger with John Thompson & Son Ltd of Horninglow Street. This doubled the size of the company and a new board was duly elected. Frederick Hurdle became chairman (his grandson Michael Hurdle would also serve in the same role until 1999) and Alfred Yeomans was managing director, and H. E. Sugden, F. Thompson and F. G. S. Holbrooke also came onboard.

They decided to centralise production. In 1898 the chance came to lease the Albion Brewery on Shobnall Road, which had been built for Mann, Crossman & Paulin. The brewery also had an ample supply of local water and its own railway line.

In 1838 a Scotsman called Peter Walker, who was brewing in Liverpool, developed a remarkable fermentation system. By arranging casks in double rows and installing a swan neck on top of each cask, excess yeast would foam up the swan neck and collect in a trough. Here the beer/yeast mixture separated and the beer would flow back into the casks. This remarkable invention would be used countrywide but became forever linked to Burton upon Trent, becoming known as the Burton Union System. During the nineteenth and into the twentieth century, all brewers used this system for their pale ales. An example of one of the Bass sets can be seen in the National Brewery Centre car park and Marston's still brew their cask Pedigree in Unions.

Views of Ind Coope and Allied Breweries

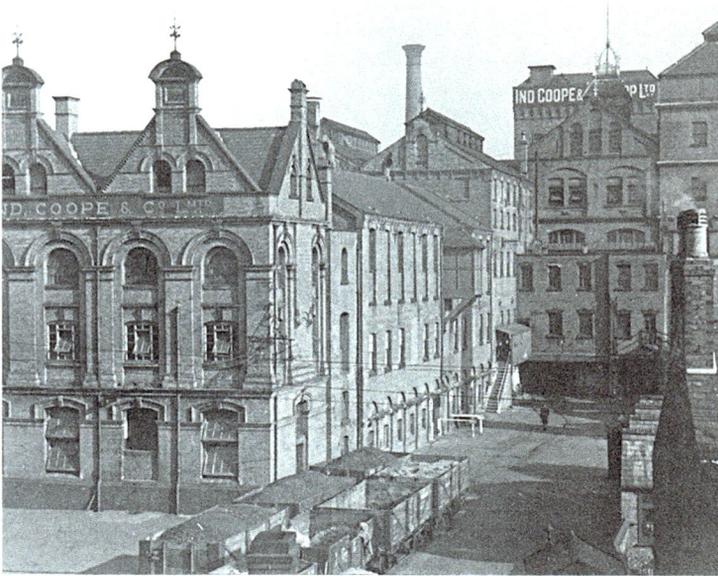

Ind Coope & Co.
Ltd's brewery
(*c.* 1910). (National
Brewery Centre)

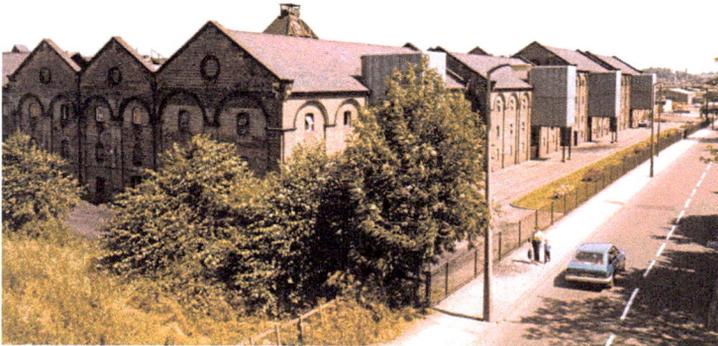

Allsopp's Shobnall
Maltings at
Shobnall Road just
prior to demolition
(mid-1981).
(Thea King)

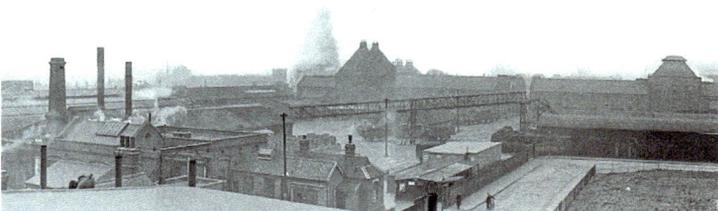

A view of Ind
Coope's Maltings,
looking down
Curzon Street to
Shobnall Road
(*c.* 1946). (National
Brewery Centre)

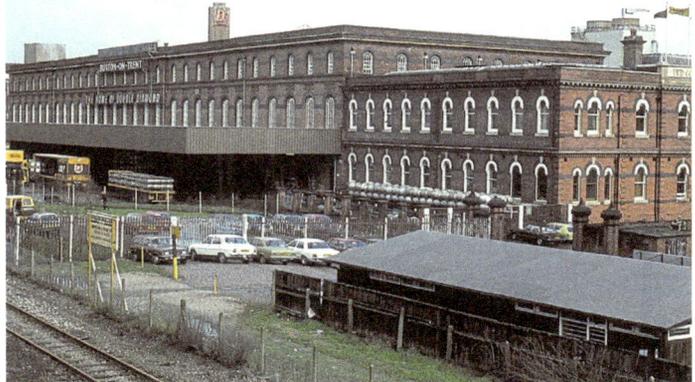

Ind Coope and Allsopp offices (*c.* 1950). (National Brewery Centre)

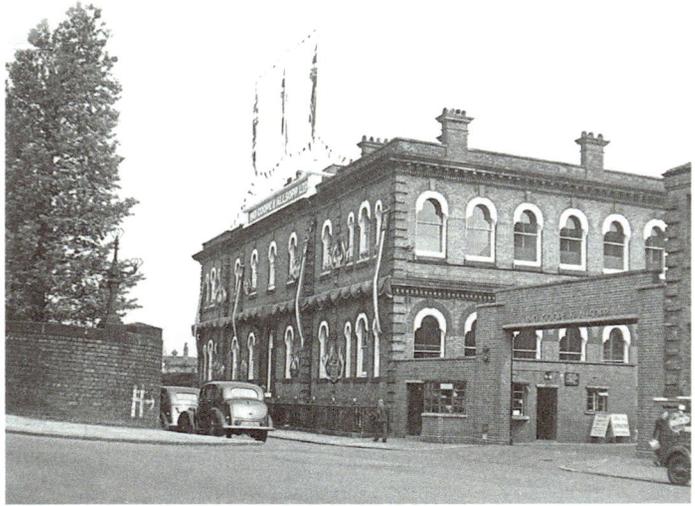

Ind Coope's 'B' Block offices (23 August 1981). (Robin Jeffcoat)

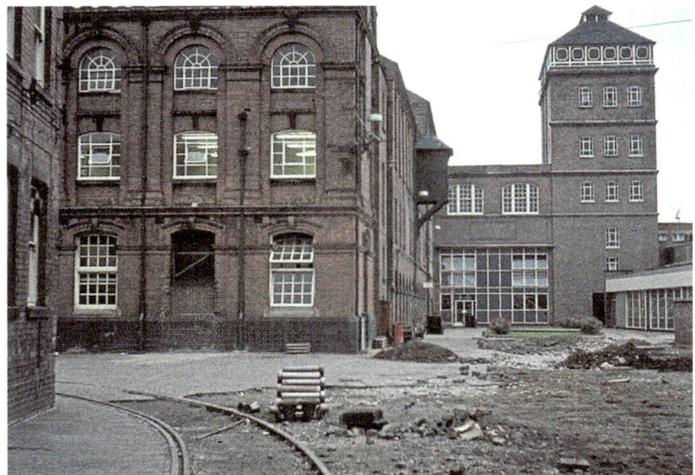

Allied Breweries' Mosley Street branch, where the track is being lifted (4 August 1965). (Robin Jeffcoat)

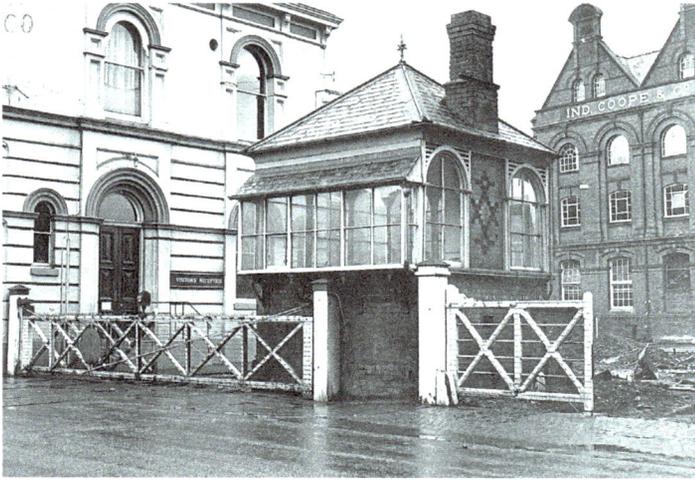

Allied Breweries' Ind Coope signal box (18 September 1965). (Courtesy of Philip Stanbridge)

Allied Breweries, Ind Coope's brewhouse (10 August 1969). (Robin Jeffcoat)

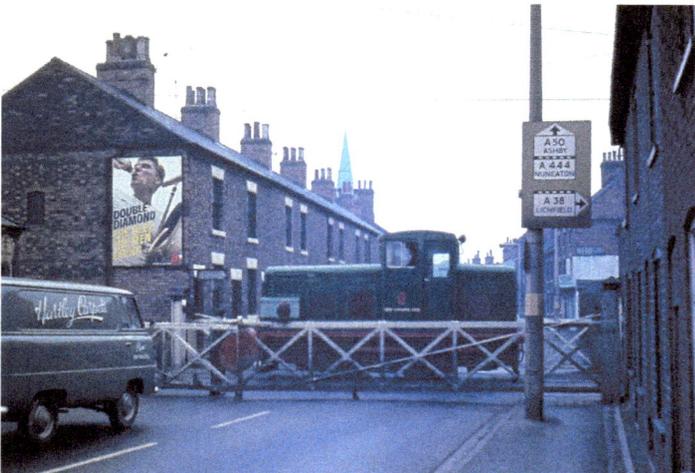

Allied Breweries' Allsopp branch. The crossing at Horninglow Street with Trinity church spire in the background (14 October 1965). (Robin Jeffcoat)

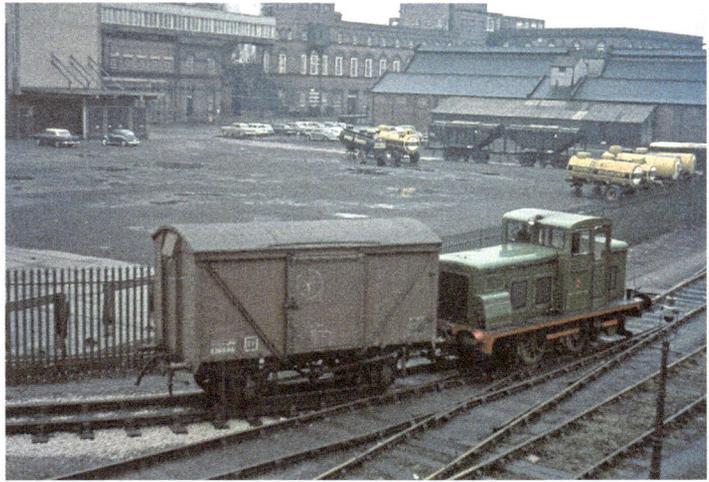

Allied Breweries'
Allsopp branch
(28 January 1966).
(Robin Jeffcoat)

Allied Breweries.
This is the site of the
Guild Street branch
and Allsopp branch
crossing. Bass' wall is
on the left (11 February
1970). (Robin Jeffcoat)

Ind Coope's Curzon
Street bottling stores,
seen from Wellington
Street East (23 August
1981). (Robin Jeffcoat)

5

The Late Nineteenth Century

Limited Success

Prior to the 1880s when a brevery needed an injection of capital, it involved the taking on of a new partner. Michael Thomas Bass took on John Ratcliff and later John Gretton; by 1851 Henry Allsopp had Henry Townshend, Henry Blundell Leigh, James Finlay and Thomas Poyser as directors, although both companies remained privately owned.

In 1871 a new article of agreement was drawn up at Bass. The total capital was £1.6 million and was distributed among the partners as follows: Michael Thomas Bass II (six shares); Richard Ratcliff (two and a half shares); Michael Arthur Bass, J. Gretton and F. Gretton (two shares each); and J. S. Clay (one and a half shares). This lasted until 1879 when another agreement was drawn up. This time the capital had doubled to £3.2 million and allowed two new directors to join – Robert Ratcliff and C. J. Clay.

In January 1888, Bass, Ratcliff & Gretton Limited announced that they would become a Public Limited Liability Company valued at £4.08 million and trading under the name Bass & Company Limited. They invited the general public to buy part of the business. The directors held onto the debenture shares, while the ordinary shares were put up for public sale.

Others also became limited companies: Burton Brewery Co. in 1887; Worthington's, John Thompson, Nunneley's, Bindley's and Ind Coope in 1888; Thomas Sykes in 1889; Marston's and Charrington's both in 1890; Salt's, Eadie's, Beard, Hill & Co. in 1893; Robinson's in 1894; Albion Brewery in 1896; John Bell in 1897; and Truman, Hanbury & Buxton around 1900. However, not all were sold to the public. Some, like Ind Coope, divided the shares between the existing directors.

'The Allsopp Fiasco'

By far the most interesting story though belongs to what was referred to by the press as 'the Allsopp Fiasco'. In February 1887 the company was offered for sale to the public as Samuel Allsopp & Sons Ltd with a price tag of £3.3 million and the public went crazy.

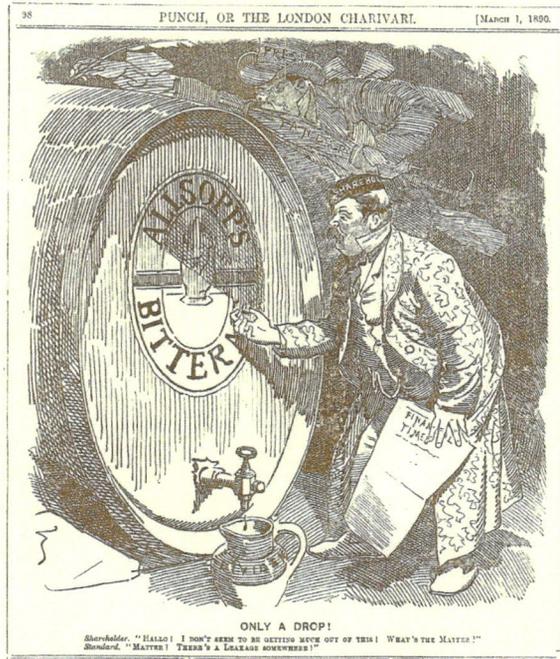

'Only A Drop' cartoon from
Punch, aka *The London
Charivari* (1 March 1890).
(National Brewery Centre)

Some reports showed £100 million had been pledged; however, within three years
those lucky enough to get shares were regretting having anything to do with the
company. Following the death of Henry Allsopp, it was Samuel Charles Allsopp who
led the company into public ownership; from the sale he made a cool £481,000.

The problem lay in the distribution of shares; staff at the London & Westminster
bank, who handled the sale, were given shares in preference to Allsopp customers. No
wonder some were declaring 'that they would never sell another drop of "Allsopp"'.
By late 1890 Samuel Charles Allsopp resigned (shamed perhaps by selling a company
that had been overvalued), leaving two Allsopp family members on the board – George
and Alfred Percy Allsopp. Following further resignations, Alfred Percy Allsopp found
himself in control and the story went from bad to worse; he began buying tied houses
at vastly inflated prices. After an excellent year of trading in 1898, the company issued
another £1.1 million in shares and, incredibly, the public bought them! Alfred Percy
Allsopp did oversee one success by converting the Old Brewery on the High Street into
Allsopp's Lager Brewery in 1899; however, this would take decades to bear fruit as
Skol Lager. He resigned in 1900. It later emerged that he had spent £2 million in two
years and that many of his investments had been unwise, leaving debts of £1.5 million.
A full report was commissioned in 1904, and when it arrived eighteen months later it
appeared in the press with the headline, 'How a million was lost'. George Allsopp died
in 1907, signifying the end of the family's involvement in the business.

Brewers in Public Life

Along with providing employment for the townsfolk, the great brewers also played an important part in other areas of town life. The first generation of brewers made their living not only from beer but other forms of trade, being involved in every aspect of the business, while the second generation inherited an established business and were able to concentrate solely on brewing. The third generation were men of privilege by the time they took control, having been born into money and high society. They employed managers to take care of the day-to-day business, leaving them time to become involved in politics; firstly at a local level, and then nationally. They lived not on the brewery premises as their fathers and grandfathers had, but in mansions outside the town.

Take the three generations of the Bass family, for example. William Bass (1720–1787) was the self-made man who through sheer hard work and good fortune was able to found a brewery. Michael Thomas Bass I (1759–1827) was the great brewer who built the business up to be the most important in Burton, playing a significant part in town life including serving as townmaster in 1794. Lastly, Michael Thomas Bass II (1799–1884), who was made a partner in 1830, delegated his responsibilities and took an interest in national politics, serving as the Liberal MP from 1848 to 1883 as a great advocate for the free trade, the working classes and, of course, the brewing industry.

Michael Thomas Bass II looked after his employees; he established a library, arranged for medical treatment, encouraged sporting activities, opened a Post Office savings bank and would hold a ball annually at his house, Rangemore Hall. In 1874 he paid £56,000 for the building of St Paul's Church; he also provided the money for the St Paul's Institute (later the town hall). Other brewers emulated Bass: Horninglow Parish Church was built in 1864 with help from John Marston; John Gretton donated £20,000 towards Winshill Church; Sir W. A. H. Bass donated £30,000 for All Saint's

Michael Thomas Bass 1760-1827

Michael Thomas Bass I (1760–1827). (National Brewery Centre)

Michael Thomas Bass II (1799–1884).
(National Brewery Centre)

Michael Arthur Bass, 1st Baron Burton
(1837–1909), *Vanity Fair*, November
1908.

in 1903; and in 1901 Lord Burton donated to the founding of St Chad's Church. Brewers were continually asked to contribute to clubs and charitable causes, and more often than not this was looked upon favourably.

William Henry Worthington was the chairman for the Board of Town Commissioners from 1853, while other brewers – namely John Gretton, George Meakin and Joseph Nunneley – served as commissioners. When the town of Burton became a municipal borough in 1878 and William Henry Worthington was duly elected mayor, five of his seven aldermen were brewers: Sydney Evershed; Samuel Charles Allsopp; Michael Arthur Bass; H. Wardle (from Salt's); and J. Yeomans. When Burton became a county borough in 1901, it was thanks to these gentlemen. Other brewers also served as mayor: Sydney Evershed; George Allsopp (his name is on the Andressey Bridge); Arthur Coxon; Francis Thompson; and George Blackhall.

Henry Allsopp represented Worcester in Parliament from 1874 to 1880, Michael Arthur Bass represented firstly Stafford from 1865 to 1868 and then East Staffordshire from 1868 to 1886, Henry Wardle represented the South Derbyshire division and Hamar Bass represented firstly Tamworth and then West Staffordshire. Unlike Michael Thomas Bass II, these brewers were Conservatives due to the Liberal Party's support of the Temperance Movement.

Henry Allsopp was raised to a baronet in 1882 and then a peerage in 1886, adopting the grand title of 'Lord Hindlip of Hindlip and Alsop-en-le-Dale'. He died the following year and the title was inherited by his eldest son, Samuel Charles Allsopp, who served as MP for Staffordshire East and then Taunton. His brothers, George Higginson Allsopp and Alfred Percy Allsopp, were MPs for Worcester and Taunton respectively.

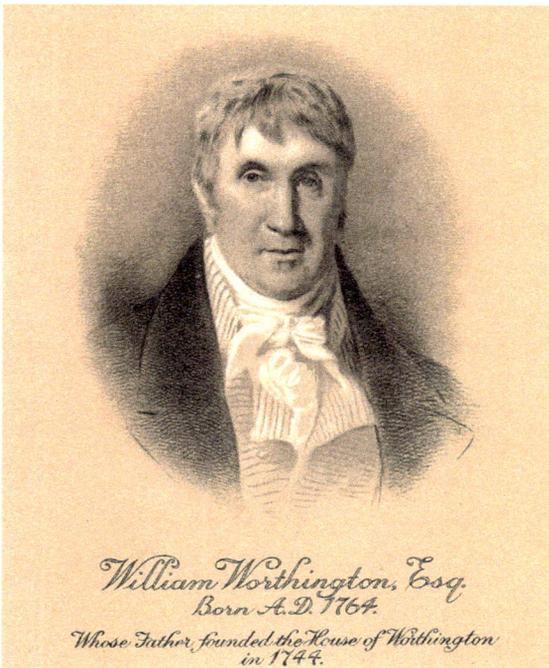

William Worthington, Esq.
Born A.D. 1764.
Whose Father founded the House of Worthington
in 1744.

William Worthington II.
(Neil Buxton Collection)

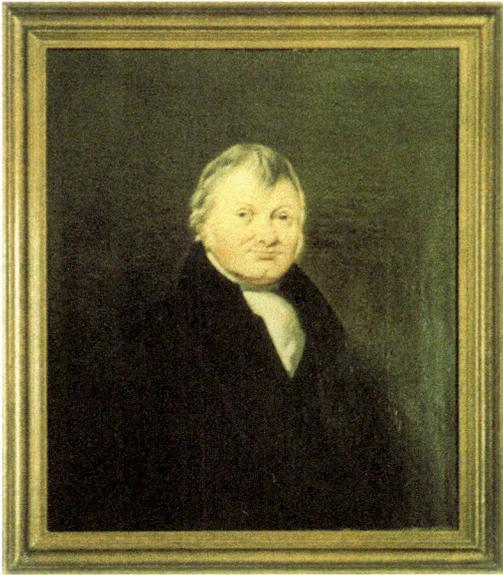

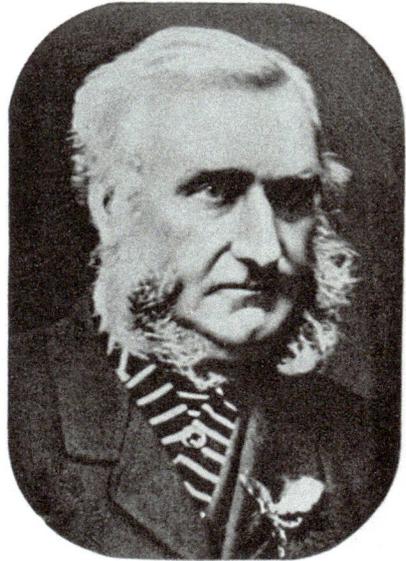

Above left: John Marston
(1785–1846). (Marston's PLC/The
Magic Attic)

Above right: Sir Henry Allsopp, 1st
Lord Hindlip. (National Brewery
Centre)

Right: Samuel Charles Allsopp, 2nd
Lord Hindlip (1885), *Vanity Fair*.

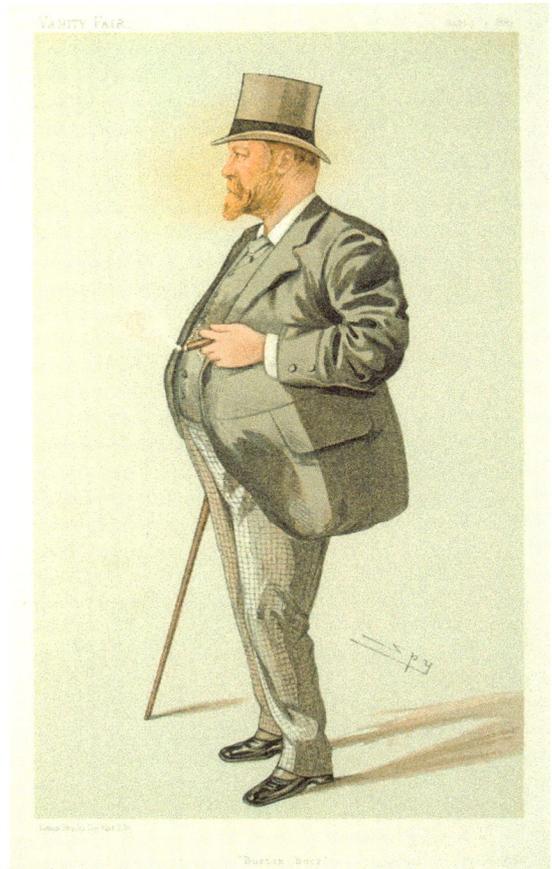

Henry Allsopp provided a social club on Brook Street and by 1887 the company had given employees a library, a cricket ground and a bowling green, as well as a sick and funeral club. Many of the breweries threw Christmas parties; Allsopp gave out Christmas beef for decades and there were annual trips to the seaside and places like Crystal Palace.

When Michael Arthur Bass became a baronet in 1882, his father was still alive but had turned down all honours offered to him. In 1886 he became 'Baron Burton of Rangemore and of Burton-on-Trent'.

The brewers built estates outside the town: Henry Allsopp built Foremark Hall and later Doveridge Hall; John Gretton built Bladon House and later Drakelow Hall; Hamar Bass built Byrkley Lodge; Michael Thomas Bass II built Byrkley Lodge and later Rangemore Hall; G. H. Allsopp built Foston Hall; J. Eadie built Barrow Hall; R. Ratcliff built Newton Park; and W. C. Salt built Willington Hall.

As the brewing industry developed, so did ancillary industries. R. Morton & Co. on Derby Street built brewing equipment and S. Briggs & Co. of Moor Street specialised in refrigeration and steam engines; these would expand to fill orders not just from Burton but countrywide, and even abroad.

The processing of brewery by-products, such as hops, spent grains and yeast, became big business in its own right. This lead to companies like Marmite Food Extract Co. Ltd (originally based in Cross Street), English Grains Ltd on Derby Road and Oxford's Patent Ltd on Fleet Street.

Specialist cooperages appeared, including J. Burman & Son of Hawkins Lane, Edwards & Co. on Dale Street, J. W. Grout & Co. of Dallow Street, and Hill Bros. and J. Morris & Son, both of whom were of Horninglow Street. Companies also specialised in malting, with the most important being Lewis & George Meakin. After Meakin sold his Abbey Brewery to Charrington & Co. in 1872, they opened their first malting block on Anglesey Road (then known as Kimmersitch Street) in 1875. Another was opened in 1882 and by 1887 the company had three managers, six foremen and seventy maltsters in their employ. Other dedicated maltsters included R. Peach & Co. on Station Street, Richards & Co. on Horninglow Street and Yeoman's, Cherry & Curtis on Shobnall Street.

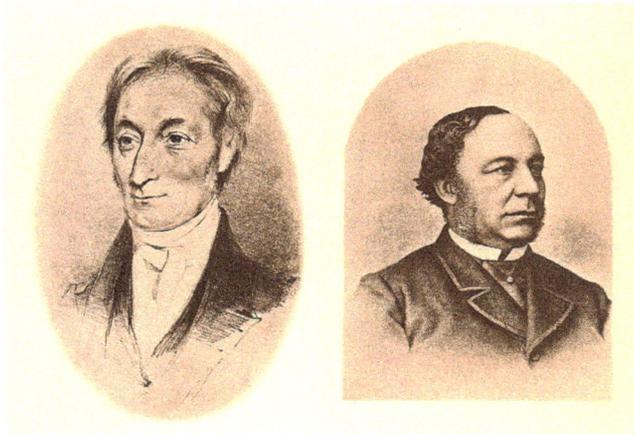

Edward Ind and
W. O. E. Coope. (Author's
Collection)

Views of Marston's

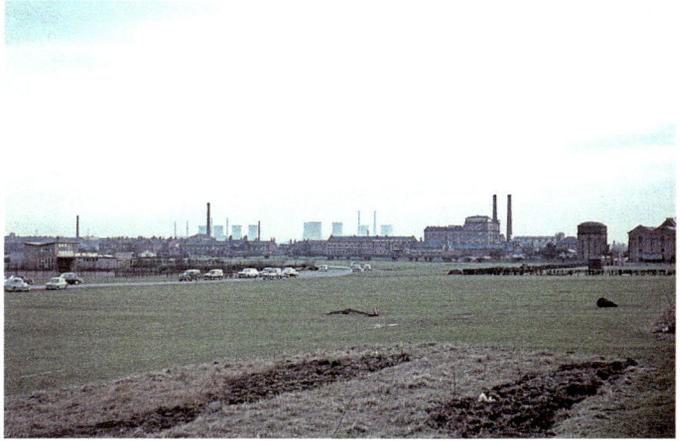

Marston and Allied's
maltings seen from
Shobnall Fields
(14 February 1965).
(Robin Jeffcoat)

Marston's Brewery,
seen from the A38
construction site;
note the Club being
built (2 May 1967).
(Wilfrid Jeffcoat)

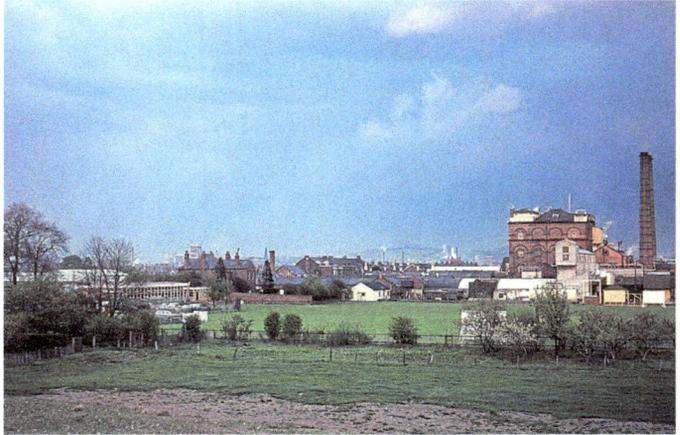

The remains of
Marston's Maltings
at Horninglow Street
and Dover Road
(23 February 1966).
(Wilfrid Jeffcoat)

Marston's Horninglow Street Maltings, opposite the current police station (23 October 1968). (Robin Jeffcoat)

Marston's Horninglow Street Maltings showing demolition of 12–17 Horninglow Street. The Guild Street branch is to the rear (17 July 1969). (Robin Jeffcoat)

John Thompson's yard (later amalgamated with Marston), Horninglow Street, with Clay House in the background (28 June 1970). (Robin Jeffcoat)

Marston's Park Street Maltings are on right. Asda and its associated car park now occupies the site (10 September 1967). (Robin Jeffcoat)

Marston's Park Street Maltings. This is looking in the opposite direction to the previous view (27 August 1979). (Robin Jeffcoat)

Marston's Crossman Street crossing (9 May 1968). (Robin Jeffcoat)

6

The Twentieth Century

Amalgamations, Takeovers and Bankruptcies

If the early years of the nineteenth century had been a difficult time for the brewers of Burton, the picture was just as bleak a hundred years later. As the new century dawned there were twenty-four breweries; by 1924 this number had halved, and by the time Ind Coope had amalgamated with next-door neighbours Samuel Allsopp in 1934 that number stood at just six!

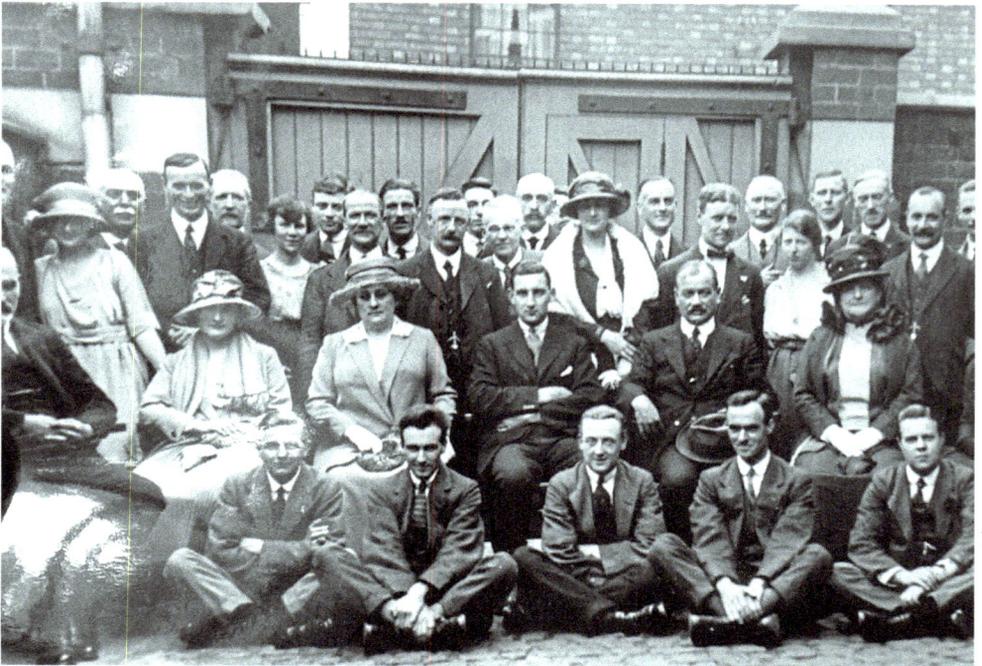

Colonel Jim Eadie (grandson of James Eadie) and workers in around 1925. (Eadie Family Collection)

There were many factors at play, such as a general downturn in the beer market, a rising temperance movement, poor financial management and so on. The smaller breweries did not have the capital to compete so this led to amalgamations between the big and the small, although in truth many of these were, in fact, takeovers. The new business could then be 'consolidated'; this usually meant that the smaller brewery was closed down while the tied estate was retained. The likes of Bass, Marston's, Allsopp and Ind Coope began to look further afield than Burton and began buying up struggling breweries from other parts of the country.

The casualties in Burton included: John Bell & Co. Ltd, who had gone public in 1897 and were sold to Thomas Salt & Co. Ltd; Thomas Cooper, who was bought by Worthington's in 1901; and John Beard was bought by J. Marston & Thompson. All of these occurred in 1901. Ind Coope, Salt and Allsopp almost merged in 1906. The following year, Allsopp was linked with Burton Brewery Co. and Salt, but this came to nothing. Ind Coope went into receivership in 1909 and reformed as Ind Coope & Co. (1912) Ltd. Samuel Allsopp & Sons Ltd also went into receivership in 1913; John J. Calder was appointed to run the company, which he did very successfully. When Bindley's were sold to Ind Coope in 1914, Director Gerald Thorley joined the new board, and would be instrumental in turning the business around.

Brunt & Bucknall sold to Salt in 1919 and Thomas Robinson sold to Ind Coope in 1920, with brewing continuing for nine years. A. B. Walker & Son sold to Bass in 1924, Charrington ceased brewing in Burton in 1926, and Thomas Salt & Co. Ltd sold to Bass. In 1927 Burton Brewery Co. Ltd sold their premises to Worthington, who renamed it Worthington's No. 2 Brewery and the business was eventually sold to Ind Coope in 1928. James Eadie sold to neighbours Bass in 1933.

Marston's acquired D. Pettifor & Sons of Anstey, Wright's of Market Drayton and Ealand's of Southwell, Nottinghamshire, adding maltings and, more importantly, pubs to their estate. Their biggest acquisition though was Evershed's. Following the death of

The original Ind Coope bottling stores (1946). (National Brewery Centre)

Sydney Evershed in 1903, the company fell into the hands of his sons, Percy and Sydney Albert. Having brewed at the Angel Brewery since 1854, there was geographically little room for expansion and in 1905 they accepted an offer of £206,000 to become part of Marston, Thompson & Evershed Co. Ltd. Their estate included seventy tied and sixteen leasehold pubs as well as the brewery; additionally, there was a cooperage and a maltings in Park Street and Fleet Street. The Angel Brewery ceased production in 1908.

By far the biggest brewery was Bass. In 1902 it covered 750 acres of land, had 17 miles of railway lines and employed 3,500 people in the town, along with many more at branches all over the country as well as overseas in Paris and the United States. The company continued to grow, merging with Worthington's and Salt's in 1927 and Eadie's in 1933. The name Worthington still survives with beers like White Shield and Creamflow.

Between 1900 and 1919 four new breweries were established in the town, but they weren't to last: the Exors of E. Wright (1905–19); T. W. Thompson (1900–09); Magee, Marshall & Co. Ltd (1901–03); and the shortest-lived brewery in Burton's history, E. & J. Miller Co. Ltd, who bought their brewery from Wright in 1919 and sold it to Salt in the same year!

Rivals no More

Divided by only a brick wall in the case of Ind Coope and Samuel Allsopp, and the width of the High Street for Bass and Worthington, the period 1927 to 1934 saw these four great companies become two.

After failed attempts in 1906 and 1911–12, Ind Coope & Allsopp Ltd became reality in March 1934. To signify the event, a section of the dividing brick wall was demolished and the two railway systems were connected. Run by a board headed by John J. Calder (Allsopp), Col. Sir George L. Courthope (Ind Coope) and Clement Thorley (Ind Coope, latterly of Bindley's), Ind Coope were the controlling partner. They had more assets than Allsopp and were making twice the profit. The merger meant that there would be duplication at the management level; the Ind Coope man became the head of department while his Samuel Allsopp counterpart became his deputy.

Since 1910 the Bass board had seen the withdrawal of the influence of the Bass, Ratcliff and Gretton families. Failing to see the need to buy up smaller breweries, they instead opted for the Worthington merger in 1927. It was a logical move in certain ways. For their size, both had fewer tied houses than expected; they relied on agencies and trading agreements, so it made sense to consolidate these resources. Bass and Worthington had been great rivals for years and little changed post-merger. Both businesses carried on operating separately and the inter-brewery divisions still ran deep. It was described by Bass historian K. H. Hawkins as 'Probably the biggest non-merger in the history of the brewing industry.'

Marston, Thompson & Evershed had already amalgamated in the early 1900s so the company was able to concentrate on growth. Evershed's Brewery was dismantled and brewing was centralised at the Albion Brewery. The former Thompson Brewery had a hop store added and a bottling plant was built at Coventry. Their beers began to win awards; for instance, a bottle of pale ale won gold at the Brewer's Exhibition

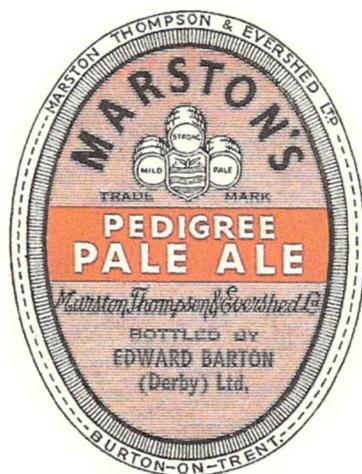

The first Marston's Pedigree label (1952).
(Keith Osborne)

in 1912 and 1913. Before the outbreak of the Second World War in 1939 they had acquired another nine breweries, and with it a vast estate of tied houses. The plan was effective: buy up a struggling small brewery (usually in the Midlands), close the brewery, use the premises as a depot and supply the pubs with Marston's beer!

The 1930s saw four Marston's directors pass away in the space of four years. They were replaced by the next generation, with F. O. N. Hurdle becoming chairman. The outbreak of war brought about rationing and brewers were told to reduce their barley consumption by 10 per cent. Rather than compromise on quality, production of their premium barley wine Owd Roger, first brewed in 1908, was suspended.

Late Twentieth Century

Between 1935 and 1971 there were just five breweries left trading: Bass Worthington; Ind Coope & Allsopp (aka Allied Breweries); Marston; Truman; and Everard. This

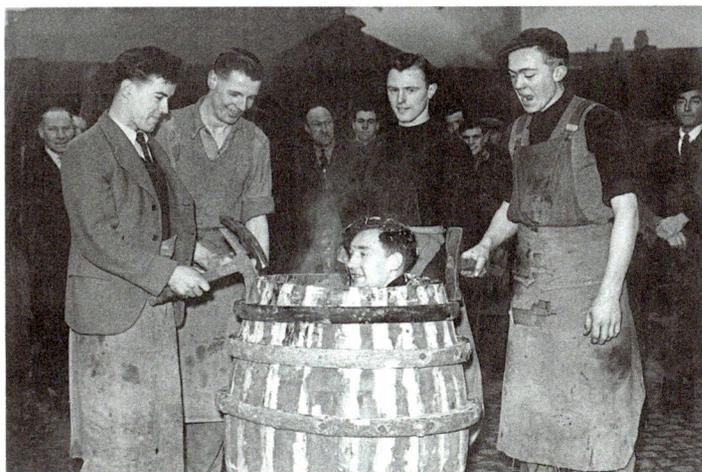

Bass cooper
Bill Schofield
being trussed-in
(16 January 1951).
(Bill Schofield)

dropped to an all-time low of four when Truman's ceased brewing on Derby Street in 1971 (although the brewery name lives on with Black Eagle Court).

When the Museum Brewery (aka White Shield Brewery) was founded in the Bass Museum in 1979, it had been sixty years since the last brewery was established. Using a seven-barrel plant that had originally been part of Mitchell & Butlers experimental brewery in Birmingham, they specialised in limited runs of ale. It now brews as the Heritage Brewing Co.

Heritage Brewery Ltd (1985–92), Tollgate (2005–15, after which they relocated to Caulke) Mundane Brewery (1992–94) and the Bevvied Bull (1997–99) all came and went. There were also other new businesses such as Burton Bridge Brewery, Old Cottage Brewery, the Tower Brewery, Black Hole Brewery, Gates Brewery and Burton Town Brewery. These are all detailed in chapter nine, 'Brewing Today'.

Bass Worthington entered the 1960s with production spread over four sites. Brewing ceased at Worthington's in 1967 and a kegging and conditioning department was built at the Middle Brewery. A modern brewery was erected next to New Brewery in 1968, called No. 1. The New Brewery became No. 2 and the Old became No. 3. Following further work on No. 2, No. 3 closed in 1969 and except for the water tower, was demolished. No. 2 Brewery closed in 1982 following a £2.6 million new build at No. 1.

To confuse matters further, Bass merged with Mitchells & Butlers Ltd to form Bass Mitchells & Butlers Ltd in 1961. In 1967 there was another merger and another name change, this time merging with Charrington United Breweries Ltd to form Bass Charrington Ltd.

In 1998 they bought neighbours and rivals Ind Coope Burton Brewery from Carlsberg-Tetley Ltd, which was then sold to Belgium's Interbrew in June 2000 for £2.3 billion – not a bad return on William Bass's initial investment of £1,050 in 1777! This gave Interbrew a 32 per cent market share, so the government ordered them to downsize. The Burton breweries and brands such as Worthington, Grolsch, Carling and Caffreys were sold to Coors in 2002. They remain the owners to date.

The post-war years were a time of massive growth for Ind Coope & Allsopp. Under the direction of new directors Sir Edward Thompson and his brother Neville, four old malting blocks on Curzon Street were converted into 'Britain's Greatest Bottling Stores'. The main product being packaged was Double Diamond, a beer that could trace its roots back to Allsopp's meeting with Mr Marjoribanks in 1822. Another innovation came in 1954 with their first canned beer, Long Life. As sales of Double Diamond took off in the 1950s, the brewery was further modernised and more subsidiary companies were bought out. Like Bass, 1961 saw Ind Coope & Allsopp enter into a big merger; initially called Ind Coope Tetley Ansells Ltd, they later became the catchier Allied Breweries Ltd in 1963. Under the direction of Sir Edward, the new concern became incredibly successful.

1952 saw the birth of Marston's most famous beer – Pedigree. Originally known simply as P or P Quality (other ales at the time included PX, PXX and PXXX), it was launched in July 1938. The origin of the name Pedigree is contested; some say it was named by then Head Brewer George Peard, others that an employee, Marjorie

Newbold, won the right to call it Pedigree in a competition. With the trade increasing for bottles, a new plant was installed in 1954. In 1957 they signed an agreement to bottle Whitbread's Mackeson Stout; then, in 1961, as the lager market started to emerge, they entered into an arrangement with Ind Coope to sell Skol in their pubs. A keg plant was installed in the 1960s and expanded again in 1971 to produce beers like Burton Keg.

Marston's still concentrated on cask ales, but also developed other beers, like Low C (originally Low Cal) in 1970, Merrie Monk (a strong mild discontinued in 1993), Pilsner Lagerbier and Nut Brown. In 1992 they launched the Head Brewers Choice, the idea of Head Brewer Paul Bayley. The concept of a limited run of cask ales would be copied by other breweries, especially Ind Coope with the Samuel Allsopp Brewing Co.

In the 1990s Pedigree was marketed as a national brand, complete with the company's first full-scale television advertising campaign. In 2005 they began to brew Draught Bass under licence. Wolverhampton & Dudley Breweries bought the brewery in 1999, but since 2005 the company has been known as Marston's PLC. It has been 184 years since John Marston brewed his first pint and Burton's last remaining nineteenth-century brewery (in name) shows no sign of stopping just yet.

Views of Other Breweries (Part One)

Truman, Hanbury & Buxton Brewery Ltd, Derby Street (21 July 1965). (Robin Jeffcoat)

Truman, Hanbury & Buxton during its demolition (*c.* 1973–74). (Wilfrid Jeffcoat)

The remains of Evershed's Angel Brewery at Bank Square. The site is now occupied by Primark (7 August 1965). (Robin Jeffcoat)

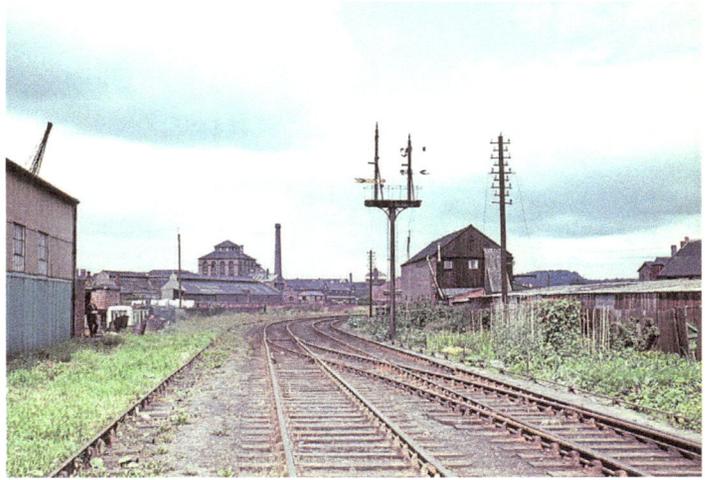

Everard's Bond End branch. The view is from Uxbridge Street towards Anglesey Road. Everard's is on the left in the distance; the site is now Evershed Way (7 August 1979). (Robin Jeffcoat)

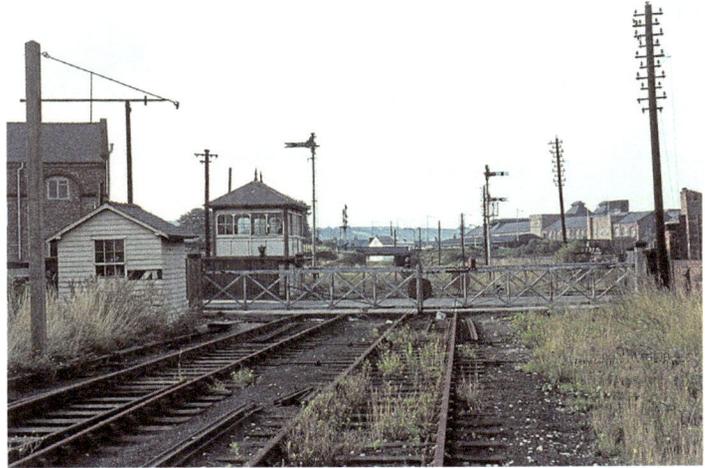

The Dale Street level crossing looking north towards Crown Maltings (later Worthington's), while Allied's bottling stores are to the right (10 September 1967). (Robin Jeffcoat)

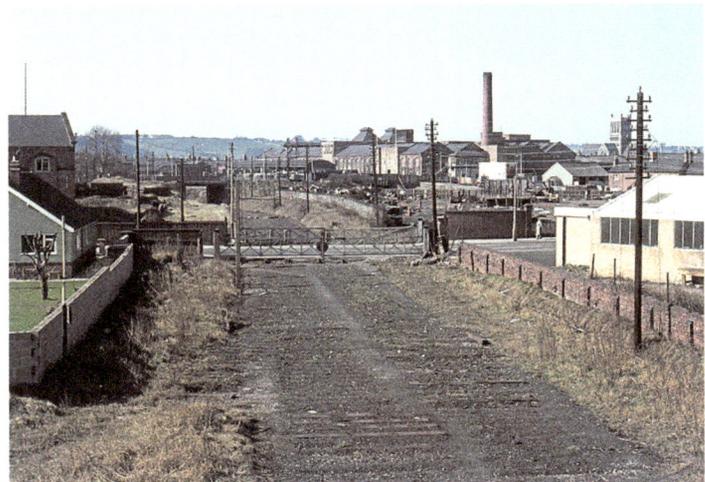

The same view but without the railway lines (6 April 1969). (Robin Jeffcoat)

7

Burton Beers and Brewery Taps

Burton and its Beers

If there have been over 100 breweries in Burton, between them they must have brewed thousands of different beers. Although forever famous for pale ales, the town has produced every type of beer popular with the home market: mild, porter, bitter, stout, lager, barley wine...

There was another style called simply 'Burton Ale', which had its origins in the beer once sent to Russia. Made less sweet and bitterer to suit home-grown palates, Burton Ale came in a variety of strengths, all of which were very strong. In 1843 Jonathan Pereira analysed samples, finding original gravities of 1111 to 1120, down to 1077 to 1092. This was much stronger than an IPA, which was around 1065.

The accolade for strongest beer ever made in Burton goes to Samuel Allsopp's Arctic Ale; as suggested by the name, a beer that was brewed especially to survive the extremes of the Arctic. With an OG of 1130 and an ABV to match of 11.25 per cent, the contract was won by Allsopp from the Lords of the Admiralty and it was first brewed in 1851. The beer would figure again in 1857 and 1875. A version of Arctic Ale would be brewed until the 1970s, called Artic Barley Wine in the 1950s and finally Triple 'A' (the three A's being Allsopp's Arctic Ale).

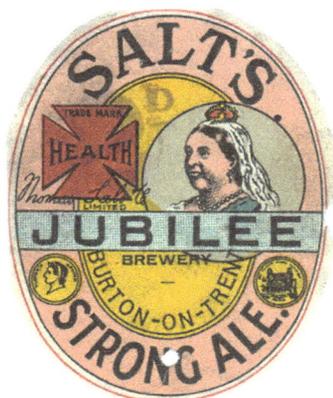

Bass' Prince's Ale and Thomas Salt's Jubilee Strong Ale. (Keith Osborne)

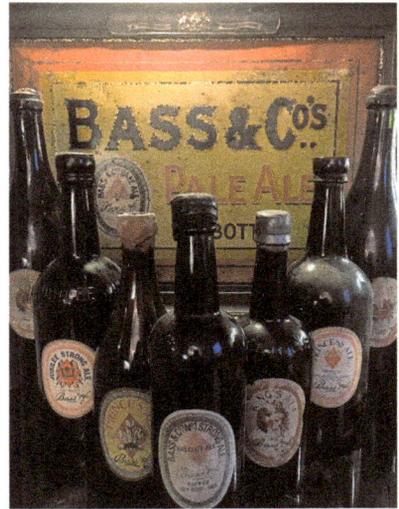

Bass 'Corkers'. (Gary Summerfield Collection)

Bass used the Red Triangle on IPA and a Red Diamond on Burton Ales, No. 1 had an OG greater than 1.100 and they also made Nos 2, 3 and 4. The best Worthington Ale was called, oddly, G. The next best was F and the third C or CK. Marston's ales had more obvious names like IPA, Strong Burton Ale, Medium Bitter Ale and Light Bitter Ale, whereas in the mid-1860s Allsopp had X, XX, XXX and F (all milds), Strong Burton Ale and East India Pale Ale.

In the mid-1800s, beers such as Burton Ale, Pale Ale and East India Pale Ale could be found on advertisements, indicating that they were different types of beer. Although the Victorians were known for their lack of clarity in naming beers, confusion has reigned in more recent times. Take Ind Coope's Draught Burton Ale (DBA), for example. Once advertised as the ale that Mary Queen of Scots drank while imprisoned in Tutbury Castle, DBA wasn't a Burton ale at all but a pale ale.

The difference between a pale ale and an India Pale Ale is hard to discern. Take Worthington's White Shield and Bass Red Triangle. Following the 1927 merger, both beers were the same brew; however, one was designated an IPA the other a pale ale. To complicate matters Bass also brewed Blue Triangle, which was the same as Red Triangle except that Blue wasn't bottle conditioned.

After a false start at Allsopp's in 1899, lager came into fashion in the 1960s and was brewed widely in the town from the 1970s. At first this was Skol at Allied Breweries and Carling Black Label at Bass. Many other lagers like Lowenbrau, Labbat's and Grolsch have also featured.

The tradition of limited bottlings to commemorate special occasions can be traced back to 1842 when Henry Allsopp marked the birth of Samuel Charles Allsopp. A bottle was laid in the foundations of a new chimney at the Old Brewery on the High Street. The most famous ales are the 'Bass Corkers', which started with Ratcliff Ale in 1869. These bottles can fetch hundreds of pounds at auction. Also highly collectable is King's Ale from 1902 and Royal Ale from 1911, which was made from the same recipe as King's Ale. There was Prince's Ale from 1929, Jubilee Strong Ale from 1977,

'Sos' Fearn (on right) in the Bass sample cellar. (Neil Buxton Collection)

Princess Ale from 1978 and Queen's Ale and Duke's Ale in 2002. Salt's brewed Jubilee Strong Ale, presumably for Queen Victoria's Golden Jubilee in 1887, Ind Coope & Allsopp's famously brewed Jubilee Ale in 1935 and Commonwealth Ale in 1953, while Marston's produced Monarch Ale in 1953 in two varieties. From the 1960s limited ales were produced for Christmas, anniversaries, retirements, royal weddings and births etc. There are far too many to list here.

Value-wise, undamaged full bottles that are over 100 years old are worth at least £100, perhaps a lot more. Bottles of Arctic Ale especially can command high prices and those from the first half of the last century may fetch £20 to £50, but those produced since may be worth £5 to £10. Other collectable items of Breweriana include ashtrays, matchstrikers, slates, jugs and so on. Pottery, especially pre-war, can be worth hundreds of pounds and was made by such renowned firms as Royal Doulton, Minton, Carlton, Sadler and Fieldings.

A Swift One after Work?

Along with breweries, Burton had a few pubs too. In 1880 there were about 160 pubs and hotels in the town. With a population of around 40,000, this was one for every 250 people! By 1911 the number had dropped to 145 and in 1960 there were just 130. As drinking habits have changed, the number of pubs has fallen, although in the last few years the trend for micropubs has seen places like the Last Heretic, the Fuggle & Nugget and the Weighbridge Inn open.

Certain pubs hold a special place in the town. Usually, the nearest tied house to the brewery became unofficially known as the 'brewery tap'. Employees have always enjoyed the fringe benefit of a beer allowance, which would have consisted of a few bottles of light ale that could be collected from a designated point and drunk while at work. Some breweries even built pubs on site like Ind Coope & Allsopp's Brewers' Arms and Bottlers' Arms. This was in addition to the unofficial allowance often enjoyed by the staff when the gaffer wasn't around!

Bass from the barrel in the Coopers Tavern in the early 1980s. (Yvonne Bradley)

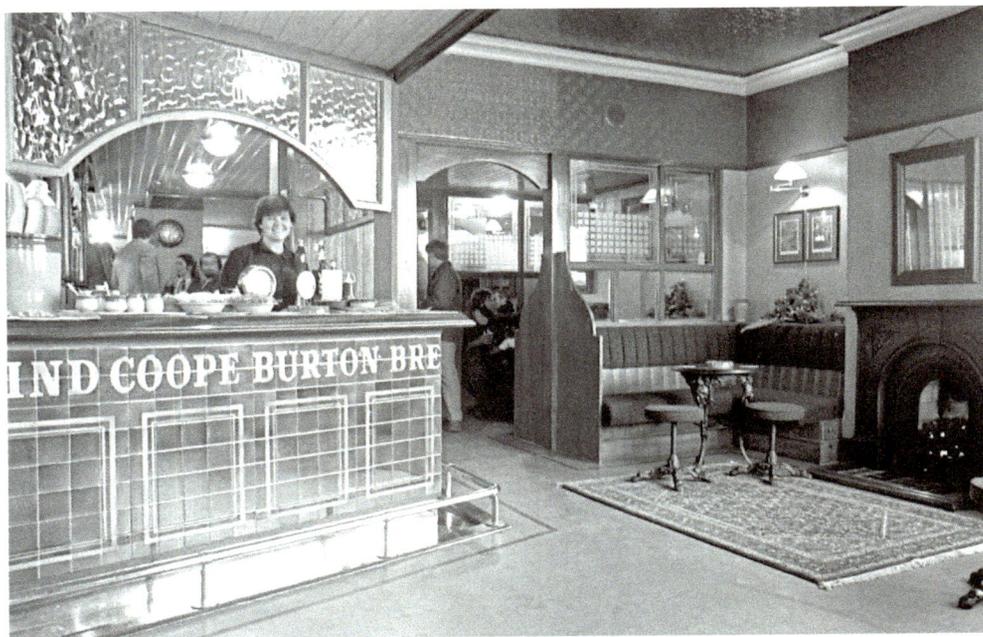

The Roebuck reopens (December 1982). (*Burton Mail*)

A full house at the Tower Brewery tap.

As the twentieth century moved on, attitudes changed. The breweries stopped condoning drinking at work and gave the option of beer tokens, which could be exchanged at certain tied houses or social clubs such as those on Belvedere Road, Wetmore Road and Shobnall Road (Ind Coope, Bass and Marston's respectively).

Brewery taps, be they officially or unofficially recognised, included the Roebuck on Mosley Street opposite Ind Coope, Charrington & Co.'s Leopard and Truman and Hanbury & Buxton's The Alfred opposite the Derby Street brewery (now a Burton Bridge house). Everard's had one house in the town, the Albion Vaults on High Street, but the most famous is the Coopers Tavern on Cross Street. Once a Bass house, it claims to have originated as the storeroom for Bass Russian Imperial Stout. Draught Bass is still served from the barrel to this day.

Other pubs fitting into the category of a brewery tap, if only for their close proximity to the parent brewery, included: Evershed's Corporation Arms on New Street; Eadie's the Devonshire Arms on Station Street; Bindley's the Foundry Inn on New Street; John Thompson's Talbot Inn on Horninglow Street; and the Coopers Arms on Wetmore Road, which was a Burton Brewery Co. house.

The concept of the brewery tap is alive and well today; Burton Bridge, Burton Town and The Tower all offer the chance to drink beers produced on the premises.

Breweriana

A collection of Bass jugs. (Paul Worthington Collection)

Thomas Salt's pottery. (Paul Worthington Collection)

A stunning array of Bass slates. (Neil Buxton Collection)

Locomotives

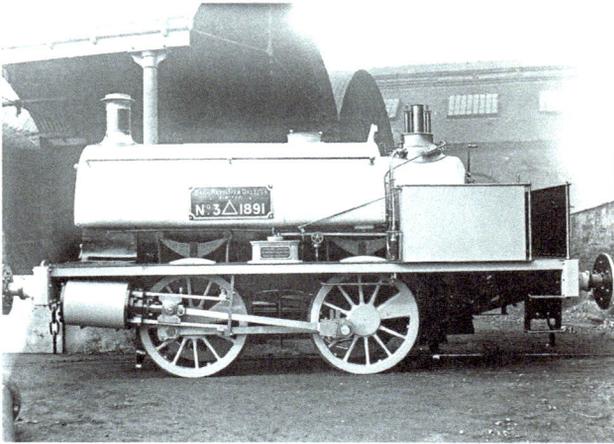

Bass No. 3, built in 1891 by Thornewill & Warham Co. (Courtesy of Philip Stanbridge)

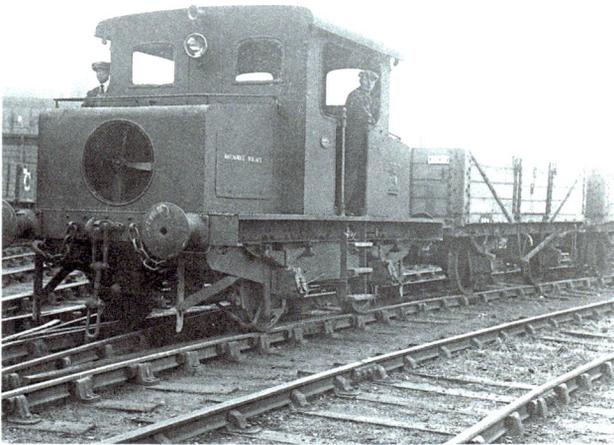

The Worthington Petrol Loco, introduced in 1924. (Courtesy of Philip Stanbridge)

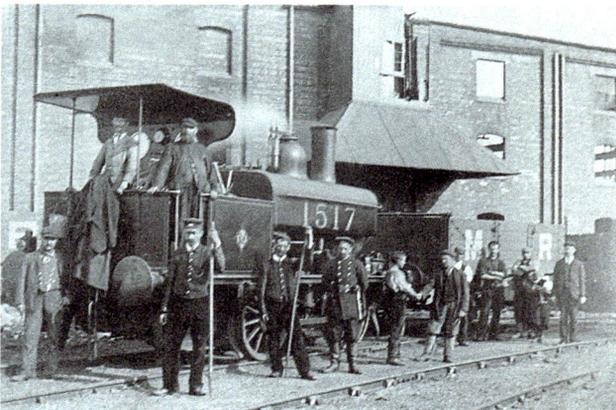

Locomotive No. 1517, Class 1116A, was built at Derby around 1897. It is seen outside Peach's Maltings following a fire (1908). (Courtesy of Philip Stanbridge)

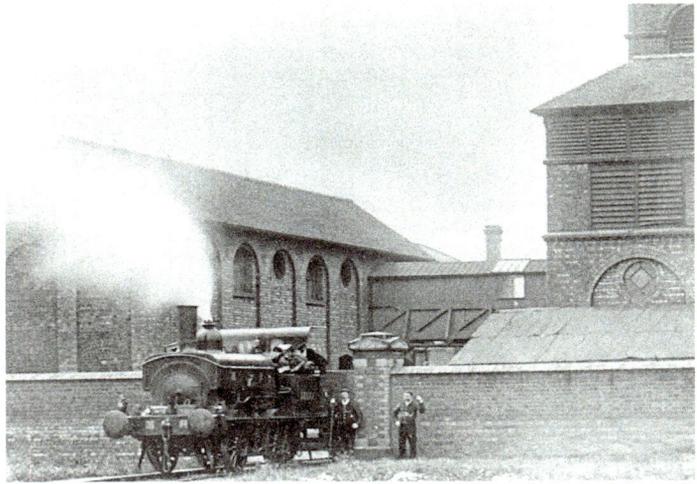

A 0-4-0 locomotive at Everard's. (Courtesy of Philip Stanbridge)

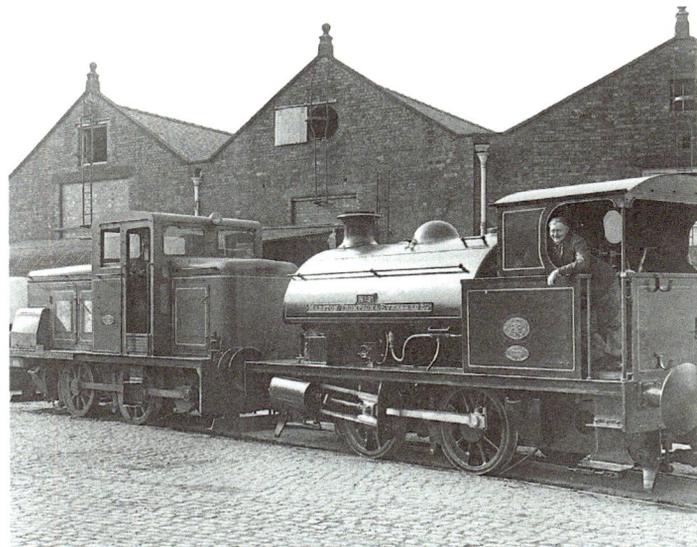

The Dixie sidings. (Courtesy of Philip Stanbridge)

Marston's Nos 2 and 3 (12 April 1967). (Courtesy of Philip Stanbridge)

8

Loss

Burton upon Trent was once a very different place. The redevelopment of the town in the 1960s, 1970s and 1980s saw vast areas of land being made available for shopping complexes such as Bargates and Worthington Walk. Like many other towns, Burton has a multi-screen cinema, a Matalan and so on, but rather than being on the outskirts, they are centralised on the vast area of land that was once Bass Middle Yard.

The changes began in 1937–8 when Allsopp's Old Brewery (aka Allsopp's Lager Brewery) on the High Street was partially demolished; the remaining buildings were used by Eatoughs for the next thirty odd years and were knocked down in 1975. Another early casualty included Thomas Salt on the High Street in 1956.

Some premises were destroyed by fire, most famously the Ind Coope & Allsopp's Hop Stores in 1954, which remains the biggest blaze in the town's history. Smoke was clearly visible 4 miles away in Repton! They also lost malthouses Nos 2 and 3 in 1962. Worthington's malt and barley stores burned down in 1974, Worthington's Maltings on Wetmore Road had the same fate in 1978, and so did Bass malthouse No. 21 in 1984.

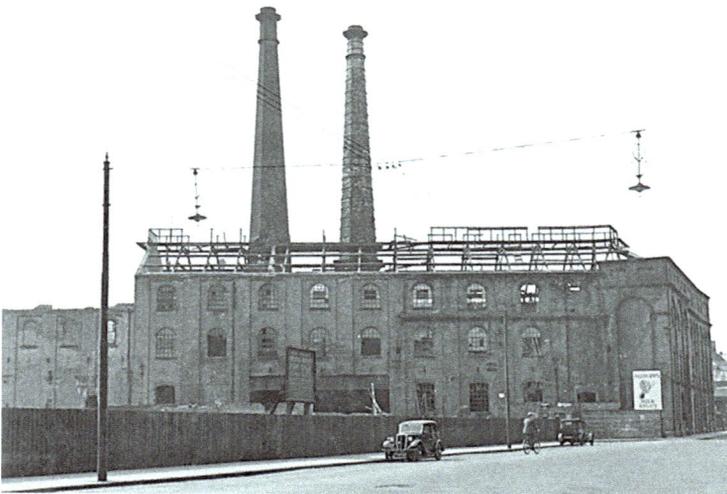

Allsopp's Lager brewery on the High Street being demolished (1937). (National Brewery Centre)

As Bass expanded and developed, some parts became redundant; Bass Middle Brewery was demolished between 1955 and 1966, as were Scutari Maltings at the Middle Brewery and Delhi Maltings at the New Brewery in 1964 and 1965–6 respectively. The steam cooperage on Middle Yard fell between 1965 and 1984, the Old Brewery was knocked down in 1970 followed by the Middle Brewery ale and hop stores from 1970 to 1976, and finally Shobnall Maltings was demolished from 1979 to 1985, which was replaced by the Tower Maltings.

The 1960s was a decade of brick dust. Allsopp's New Brewery and its stores were partially demolished, while their New Cooperage on Station Street also underwent some demolition in 1968 (finally going in 1983). Marston's offices and stores on Dover Road, John Bell's on Lichfield Street, F. Heap's on Victoria Street and Burton Brewery Co. on the High Street all fell in 1962. Nunneley's stores and cooperage fell in 1963, while the Angel Brewery on Bank Square, Bindley's on New Street, Robinson's on Union Street and Worthington's on the High Street/Station Street were all demolished in 1968. Meakin's Crown Maltings' malthouses Nos 1 and 2 on Angelsey Road and Porter's maltings on Dale Street were also lost.

The 1970s were just as unkind. Notable victims were Salt's cooperage and stores on Wetmore Road as well as part of Walsitch Maltings. Allsopp's Old Cooperage also went. Additionally, Charrington's on Lichfield Street went in 1970, part of Ind Coope went in 1971 and the Worthington Hay Maltings went in 1973, while the Black Eagle Brewery, run by Truman, Hanbury & Buxton, fell in 1975. Others included Hill's former Bond End Brewery, Sykes on Wood Street, Green & Clarkson on Victoria Street and Peter Walker on Clarence Street.

Eadie's Brewery on Cross Street and their maltings (also used by Evershed) were lost in 1981, as were Allsopp's wonderful maltings on Shobnall Road. A. B. Walker also fell in the 1980s, as did Carter & Scattergood on Victoria Crescent and Cooper's Crescent Brewery. Ind Coope's cooperage on Mosley Street was felled in 1992 and Marston's maltings by Dover Road went in the early 2010s.

The Ind Coope and Allsopp hop stores fire (1954). (Author's Collection)

Worthington Hay Maltings on fire (8 April 1974). (Robin Jeffcoat)

The remains of Worthington's Wetmore Road Maltings (6 April 1978). (Robin Jeffcoat)

Views of Other Breweries (Part Two)

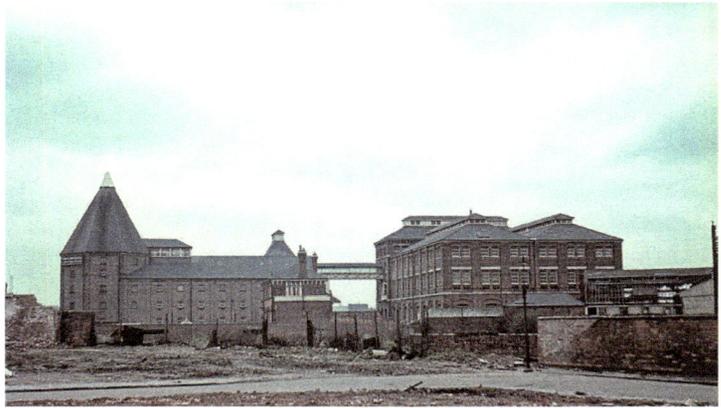

The Clarence
Street Brewery of
the Trustees of the
late Peter Walker
(1 May 1977).
(Robin Jeffcoat)

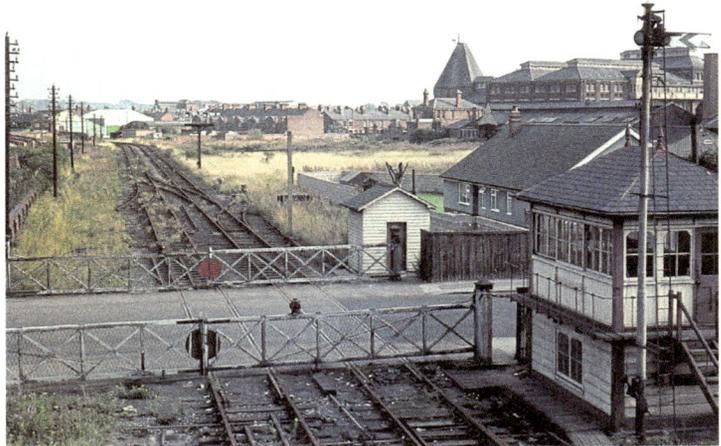

A view looking
south down the
Bond End branch,
with the Angelsey
Road level crossing
in the foreground
and the Clarence
Street Brewery
on the right (10
September 1967).
(Robin Jeffcoat)

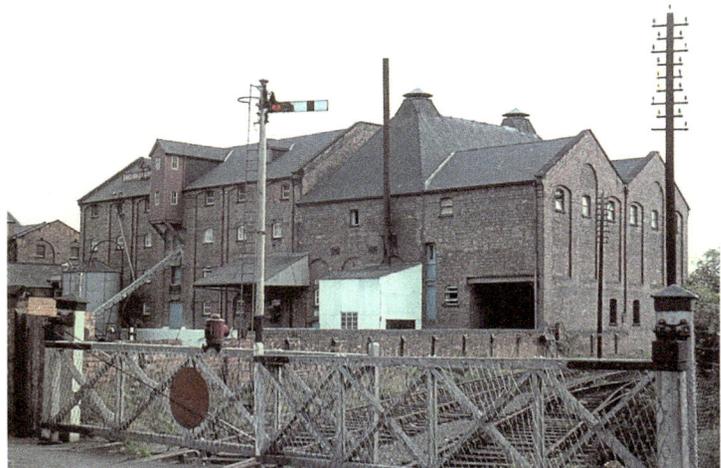

James Eadie's
Maltings on the
Union Street/Park
Street corner (10
September 1967).
(Robin Jeffcoat)

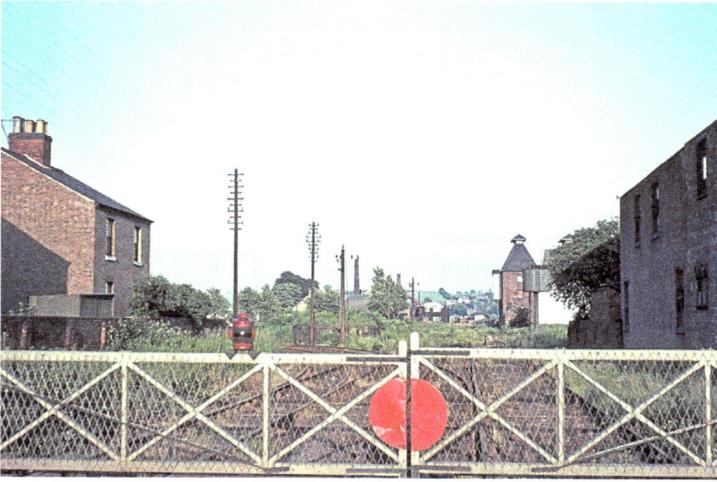

Charrington's Wood Street Maltings (27 June 1965). (Robin Jeffcoat)

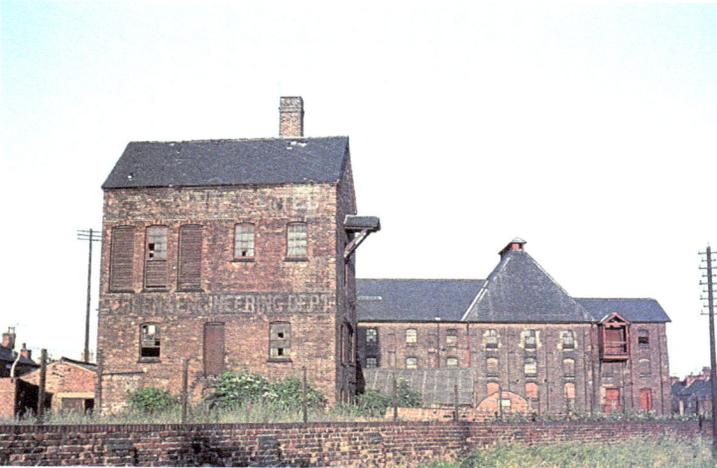

James Porter's Brewery (later Robinsons) (27 June 1965). (Robin Jeffcoat)

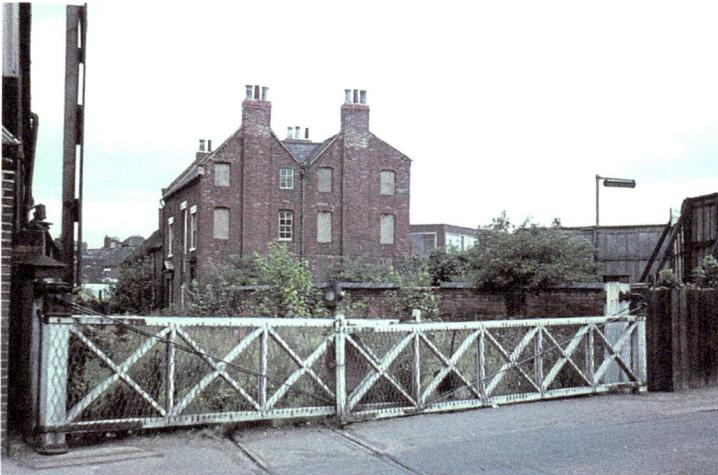

John Bell's Brewery, Lichfield Street (7 August 1965). (Robin Jeffcoat)

Bindley's Maltings, New Street. The site is now occupied by the Job Centre (22 October 1967). (Robin Jeffcoat)

Robinson's Brewery; note the Locomotive Pub on the right (22 October 1967). (Robin Jeffcoat)

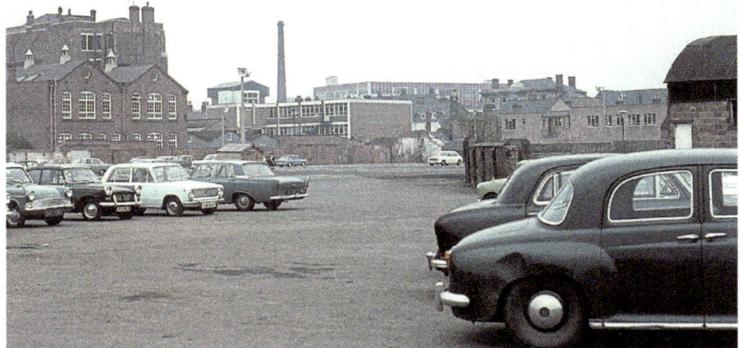

Robinson's Brewery and its cooperage (24 October 1965). (Robin Jeffcoat)

9

Brewing Today

Ranging from the major players in the industry to microbreweries, the town is currently home to nine different commercial breweries and two fledgling cuckoo brewers. Bury St Edmund giants Greene King have their head office on Ninth Avenue, although no brewing takes place on-site.

It has been around 140 years since the brewing industry in Burton upon Trent reached its peak, both as an employer and as a brewer. Today, around 1,430 people owe their livelihoods directly to the brewing, fermenting and packaging of beer. Around 1,400 people work at Molson Coors and Marston's PLC, while the remainder are at the microbreweries: there are eleven people at Burton Bridge; seven at the Heritage; five at Burton Town; four at Black Hole; two at Old Cottage, Tower and Velvet Owl; while Gates and Neon Raptor are solo ventures.

Molson Coors are by far the biggest and Marston's is next. Of the others, Burton Bridge brews at full capacity, producing an impressive 2,860 barrels per annum. Heritage produces 2,000 barrels, Black Hole 1,560, Tower 1,500, Burton Town 300, Velvet Owl 260, Old Cottage and Gates produce 150 each while Neon Raptor produces 72.

What follows is a series of interviews with all the current Burton breweries. Most were performed face-to-face and were followed by a tour of the brewery and a few pints. The author assures you that all beer consumed was strictly for research purposes only!

Molson Coors Brewing Co.

Encompassing the old Bass and Ind Coope breweries, Molson Coors are the largest brewery in town. They bought out Interbrew in 2002, which had previously purchased the business from Bass in 2000. The Bass name was retained by Interbrew and the Worthington name by Molson Coors. They are currently the third largest brewer in the world, owning around 20 per cent of the home market. Brands produced at Burton are Carling, Coors Light, Cobra, Grolsch, Doom Bar (bottled product only) and White Shield. In May 2017 they appointed a new head brewer, Andy Runcie, who said:

> I actually come from a distilling town in Speyside. Originally I undertook a degree in Brewing and Distilling, but following graduation I realised I preferred brewing to

Molson Coors' new beer processing area opening, with Andy Runcie on the right (January 2016). (Molson Coors)

distilling and began a graduate traineeship with Bass brewers. I moved to Molson Coors' Burton brewery permanently in 2000.

The rich brewing heritage of Burton upon Trent plays a vital role in my day-to-day work. Beer has been brewed on our site in the heart of Burton since 1744, and Carling, the UK's number one lager, has been brewed in the town for over four decades. From India Pale Ale to lager, you can't walk through Burton without seeing evidence of the town's rich connection with beer. Molson Coors is the custodian of this heritage and I work hard to ensure the values and history of the site are reflected in our ongoing work.

The brewery site is also home to the National Brewery Centre. Originally opened as the Bass Museum in 1977, it was closed in 2008 as a cost-saving exercise, although it was then reopened in 2010 under its current name and is currently run by Planning Solutions.

Marston's PLC

'The DE14 postcode is the centre of the universe!' exclaims Head Brewer Pat McGinty. This is so much so that their latest innovation bears the name:

DE14 is our new nanobrewery for new recipes, different ingredients ... we can experiment and then upscale to our larger plant. There are two beers that we'd like

Marston's head brewer, Pat McGinty.

to take further, both are IPAs but have subtle tweaks with the malts and we've been looking at UK varieties of hops.

The portfolio recently underwent a £1 million rebranding, aiming to attract the younger drinker; confusingly, Pedigree, which was always a pale ale, is now an amber ale.

'Pedigree has always had that amber colour, so it is accepted as amber ale in trade. We had to give it some drive, something to attract people to the brand,' explains Pat, although it is only the label that has changed. He continues:

Pedigree has retained the same recipe, although beer will evolve with time. There are subtle changes with malts from season to season, we use the same hops and the Burton Union System. Every single drop of cask Pedigree is Union brewed, the bottled is in other vessels alongside but the yeast is the same.

One beer missing from the rebrand is Owd Rodger. 'It'll always be part of Marston's,' Pat says reassuringly.

Draught Bass has been brewed under contract since 2005. 'There was a lot of work getting the flavour match right,' admits Pat. 'We went from brewing in cylindrical conical vessels at Bass to rectangle square fermenters.

When asked about Craft Breer, Pat says proudly:

We are the only brewery in the world that uses the Union System; that in itself is a craft. We have the only working cooper in a UK brewery to maintain the oak barrels; that makes us unique. The cleaning of the Unions, control of fermentation; this involves well trained skilled operatives, the Union Sets are still a manual process. This is part of our innovation. Our original craft is the oak barrel Union set. Our range of beers is wide so we fit the craft beer market in that sense.

Burton Bridge Brewery

'When we started thirty-five years ago I never told people that I was part owner of a brewery as they'd assume you were talking something like Marston's. I still don't say it as now they'd assume I am brewing in the outside toilet with a modified washing machine!' laughs Geoff Mumford, neatly summarising the changes to the industry since he, along with business partner Bruce Wilkinson, set up Burton Bridge Brewery in 1982.

By far the longest-running and most successful microbrewery in the town, they founded the business after becoming disillusioned with their then-employer Ind Coope, finding suitable premises in an ex-Bass house, the Fox & Goose on Bridge Street, which would serve as both brewery and, very importantly, a pub.

Geoff is critical of certain brewers:

There is no commitment to the brewing industry; especially with pubs. They've never been cheaper; buy a pub, brew at the pub, revitalise the pub, have your own market and good cash flow.

Nor does he have time for the current craft beer market:

I don't understand drinking cloudy beer. It's to please the landlords who ask, 'When will it be bright, when can I serve it?' With cloudy beers you can chuck it down the cellar and serve it straight away. It's the craft beer answer to Fast Cask! We are

Geoff Mumford and Bruce Wilkinson from Burton Bridge Brewery. (*Burton Mail*)

thinking of changing our strapline to 'Brewers of Exceptionally Bright Beers.' Ours do drop bright. It's a characteristic of the yeast; there's no chemicals at all.

Trading is very difficult. People start out and find it's not as big or an open market as they thought, they then sell on price; one sells at £60 a firkin, which is £15 cheaper than us. Landlords have such a choice that you can't get them to answer the phone. Something is going to happen, it's a bit like the early 1980s when the bigger players moved out and the smaller players moved in, but the bigger players now are people like us.

Burton Bridge was put up for sale in August 2016. 'It's a young man's game,' Geoff explains. 'It can still be very physical. Both Bruce and I are getting old and neither of our families want to take the business on.'

Heritage Brewery Co.

Based on the National Brewery Centre site, the Heritage Brewery Co. may have only started brewing in 2016 but the history goes back to the early days of the Bass Museum.

Steve Wellington, the head brewer, says:

When I retired from Molson Coors I was asked to open up the brewery. Five barrels in size, all copper and produced exceptionally good beer. By 2010 we couldn't cope, so I asked for a bigger brewery, I got a twenty-five barrel brewhouse for about £1.25 million. We rescued Worthington White Shield from King and Barnes, we acquired a bottling line, it took off very well, but we couldn't handle the volume so Molson Coors took it back. We brew it on draught and Coors do the bottled version.

Steve retired for the second time in 2011 and the brewery closed in 2012. After the museum was rescued, he was asked if he was interested in coming back, which he said he was.

The Heritage Brewery team. Steve Wellington is on the left.

'What I didn't realise,' he told me, 'was that we lost all the brands, especially the Worthington name. I had been producing Worthington E. We were still allowed to be called the William Worthington Brewery but we didn't brew any Worthington beers.

Steve then began to revitalise old beers such as Offilers' Best Bitter, Charrington's IPA and Oatmeal Stout:

> One of the reasons I am fond of old recipes is because anyone who could remember it is probably dead. I've been brewing since 1965 and we have the brewing books at the Museum. The brewery is nearly at full capacity. There is no automation, if a valve needs opening I want to do it myself.

Steve is due to retire for the third time: 'I am seventy-three now and I want a bit of life before I die!'

Black Hole Brewery

Founded in 2006 by Bob Shardlow and Richard Swanwick in an industrial unit on IMEX Business Park, the current owner, Carl Haspel, bought it in 2014. The brewer is Andrew Spencer, who says:

> We kept the name on and the beers, but we've made new ones for the wholesalers. Our beers are always on at Mr Grundy's Tavern in Derby which is also owned by Carl. We sell to the micropubs in Burton, we supply the Stonegate pubs, Wetherspoons, and sell a lot in Nottingham.
>
> It's easier to go through a wholesaler. Rather than ring a hundred pubs, you ring one wholesaler and get an order for 300 nines. We deal with wholesalers all over the country, so the beer is getting out there, but locally there aren't that many free houses.

Black Hole Brewery's Andrew Spencer.

Tower Brewery Co.

'I was at the Burton Bridge for just shy of ten years; I was supposed to be taking the brewing side over but at the last minute it fell through, so I found this building and raised the capital,' reveals John Mills. That was in 2000. The first pint was sold in May 2001.

John continues:

> I started out with Tower Bitter, which is still brewed; Malty Tower's a pale 4.4 per cent and Walsitch Wobbler which was a 5.2 per cent ruby beer.
>
> It's never been easy. When I started there were 250 breweries, now it's 1,700 and there are less pubs around. It is more competitive than ever. If I was setting up now, I'd think twice; it's tough! I do some free trade locally and that is getting harder due to the number of little breweries around. The big customers are Morrisons and Lidl, the IPA is in both, the Salts Burton Ale in Lidl and the Burton Strong Ale in Morrisons.
>
> I've looked at several pubs over the years; the Elms, Coopers and the Whistle, which is still empty but geographically it's not in the right place, and the Roebuck on Station Street, but they wanted too much money for that.

The Tower Brewery is in a beautiful Victorian water tower that once supplied Salt's Walsitch Maltings.

'I am lucky as I've got the venue and the bar,' says John. 'Over the last few years it has made a massive difference to the business. We do wedding parties, birthdays and we have the music, vinyl nights and live bands.'

John Mills from the Tower Brewery. (Annette Webster)

Helen Gallimore pouring a beer at Burton Town Brewery.

Burton Town Brewery

The newest brewery in town, the Burton Town Brewery, was founded in 2015 by Richard Catlin, Richard Cully, Helen Gallimore and Steve Haynes in an industrial unit on Falcon Close. Their core range has developed into Albion, Thomcat, Scorned Woman, Modwena and Burton IPA, succinctly described as 'This is a Burton Pale Ale' on the pump clip.

'We're not just a brewery,' explains Head Brewer Helen. 'We are an event business specialising in outdoor bars, festivals and weddings with its own brewery. We look at brewing from the point of customer service and end user satisfaction; I brew beers I think the public will enjoy and come back to.'

Following some turbulent times in early 2017, the future is now looking bright, with the rebranding of their Red Hand logo, the refurbishment of the brewery tap with a mural depiction of Burton's brewing history, and the shooting of a promotional video.

'I am not in this for fashion,' says Helen. 'I want to be in business for years to come and continue the traditions of Burton.'

Old Cottage Brewery

Currently in the process of being handed over to new owners, Mick Machin has run the Old Cottage for eleven years.

'Kev Slater started at the Thomas Sykes. I bought this off him when I'd had a few beers as I love the Halcyon Daze,' laughs Mick. 'I'd worked at a brewery for thirty-odd years but had never brewed beer. Alan Christie took over on 1 July 2017 with two other lads, Roger Shone and Jeff Alden.'

Old Cottage Brewery's Mick Machin and Alan Christie.

'Its good fun, I am excited about it,' says Alan. 'We will keep the same range, and are looking at promoting it more and bottling to expand sales that way. We've got Halcyon, Oak and the Stout, so we are looking at another one, maybe Dual Diamond.'

Gates Burton Brewery

'This has been my passion for thirty-odd years. I started out brewing in the kitchen. I'd make a right mess,' laughs Stuart Gates, who has been commercially brewing since 2011.
Expanding upon this, Stuart continues:

At first I could brew one barrel and then I converted the garage; I now have a three-barrel brewery. It was a hobby, but now it's a business. I supply to twenty-five pubs; there's about eight regulars and the rest have it periodically. It works nicely; if they all wanted beer at once I wouldn't be able to cope.

Stuart Gates from the Gates Burton Brewery.

I have my version of Ind Coope's DBA. I first did that twenty-five years ago, it's called GBA; Gates Burton Ale. You do have to give the market what it wants, but I am not here to make loads of money. It's rewarding when I see it in the pub, that's the buzz.

Neon Raptor Brewing Co.

Defined as a cuckoo brewer, meaning one that rents out existing brewery premises, Adam Henderson started brewing in Burton in November 2016 at Black Hole Brewery.

'My beers are different each time, mostly because I didn't have stable access to hops until recently,' explains Adam. 'They are typically on the stronger side than the UK is used to. I also like to keep them interesting so I use quite a bit of adjuncts in the beers; vanilla, coconut etc.'

At the time of writing Adam has purchased his own equipment and will cease brewing in Burton.

Neon Raptor's
Adam Henderson.
(Neon Raptor
Brewery Co.)

Liz and Richard Lesbirel of the Velvet Owl Brewery Co. (The Velvet Owl Brewery Co.)

The Velvet Owl Brewing Co.

'We focus on modern brewing techniques and experimentation with flavour combinations,' explains Richie Lesbirel, who set up the company with his wife, Liz, in 2016. 'Moll's Medicine, a session strength milk porter infused with lavender; Old Sport, an orange infused triple dry-hopped pale ale inspired by American IPAs. There will be a session pale with Ethiopian coffee and a rye porter with chipotle chillies.'

Although based in Gloucester, the Velvet Owl Brewing Co.'s first brew was at Burton Town Brewery in July 2017. They have since cuckoo-brewed at Lines Brew Co. in Caerphilly too.

'I brew beer that I would want to drink myself; never trust a thin chef! The past few years has changed the perception of what beer can be. It's an exciting but difficult time to stand out, which is why we've chosen the route we have.'

Seventy Years of Change

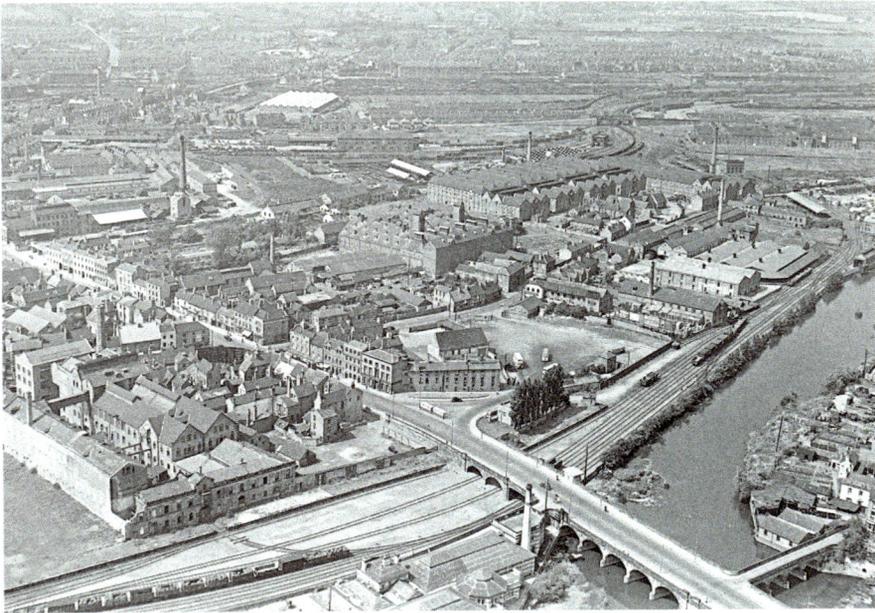

Trent Bridge and Bridge Street in 1947. (Author's collection)

The same view in 2017. (Andrew Richards)

Allsopp's Maltings at Shobnall Road in 1947. (Author's collection)

The same view in 2017. (Andrew Richards)

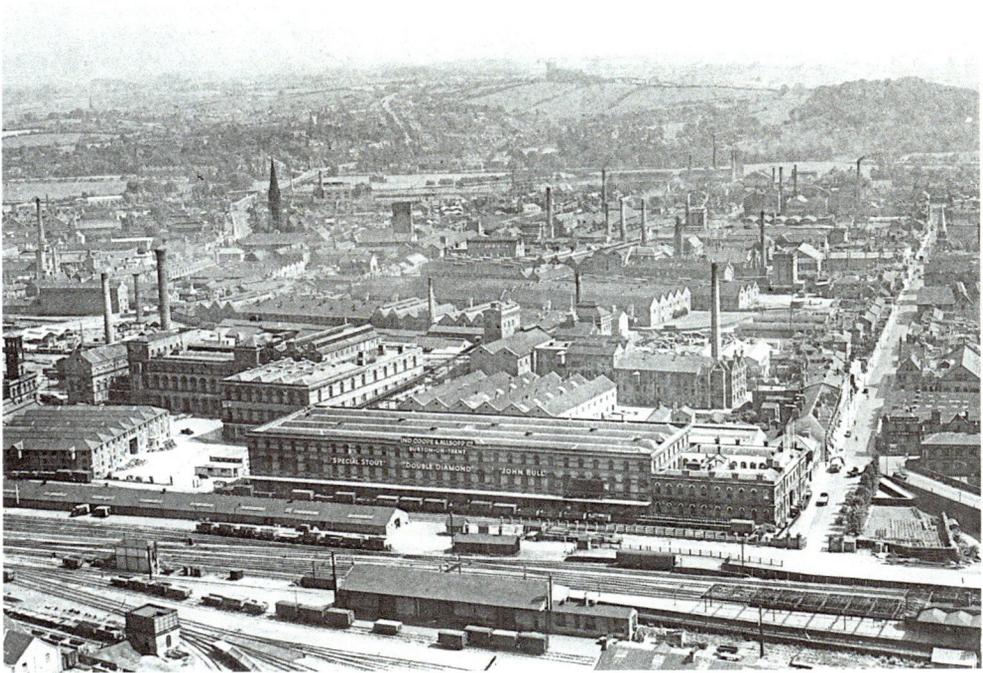

A view of Ind Coope with Allsopp in front, looking towards town in 1947. (Author's collection)

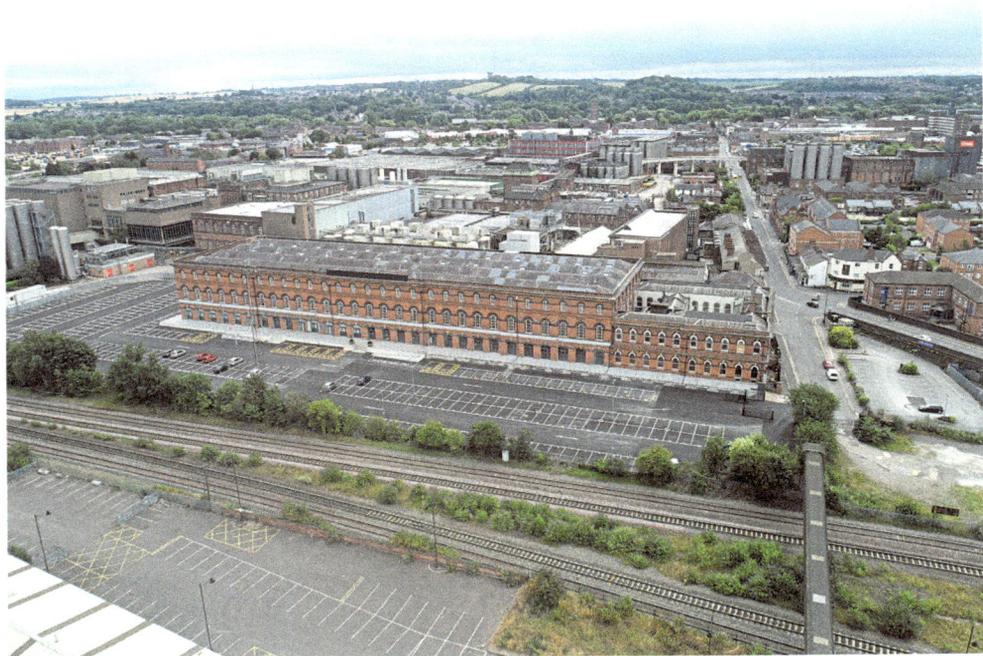

The same view in 2017. (Andrew Richards)

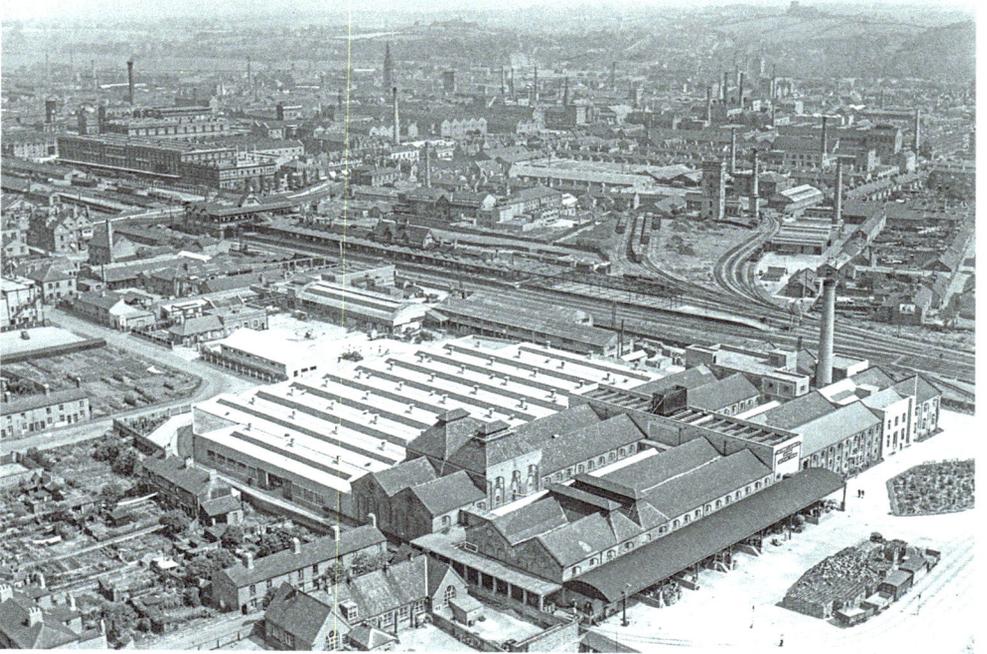

Ind Coope and Allsopp's Curzon Street bottling stores in 1947. (Author's collection)

The same view in 2017. (Andrew Richards)

Burton upon Trent
Heritage Walking Tour

Burton upon Trent
Heritage Walking
Tour

Key
Sights
Route

Introduction

In 1984, the Victorian Society published a report written by Julian Cooksey. In it he describes 'an awesome catalogue of demolition … what was formerly a fascinating and varied collection of industrial archaeology in the most famous town in brewing history has now been quite devastated.'

The trend has regrettably continued in the thirty-three years since these observations; however, there are still some fine examples of brewing architecture to be found if you know where to look, and what better way to discover the brewing history of Burton than a wander around the town?

The following tour takes in the vast majority of Burton's brewing heritage; pubs are pointed out along the way so you can stop for refreshment. The tour starts at Marston's Brewery on Shobnall Road and is approximately 4.7 miles long, taking between ninety minutes to two hours (and longer if you stop at a few pubs).

The Tour

Sight One: Starting at Marston's Brewery on Shobnall Road, see if you can smell the beer being brewed. Between the brewery and the A38 flyover is Marston's Club. Drop in for a pint of Pedigree if it is open; it's the finest drop in town.

Sight Two: Almost opposite is a 1980s property development, Price Court. This was where Allsopp's Shobnall Maltings once stood. Walk down Shobnall Road away from the A38 flyover.

Sight Three: A row of Marston's cottages are on the right. Pass the top of Grange Street and you will arrive at a small roundabout.

Sight Four: To the left is a Bass pumping house (look for the triangle windows).

Sight Five: To the right there is a row of Bass cottages, which were built in around the 1870s.

Sight Six: The 1980s Tower Maltings (ex-Bass) that replaced the Bass Shobnall Maltings. Take the first exit and walk towards a large roundabout. Go straight over.

Marston's Brewery.
(Marston's PLC)

Sight Seven: IMEX Business Park is on the left; this was once Ind Coope & Allsopp's Maltings, which were converted to bottling stores in 1947. Note that this is currently under threat of demolition. Retrace your steps to the large roundabout and turn *right*. Walk down Wellington Street until you come to the traffic lights.

Sights Eight and Nine: St Paul's Church is on the left, which was paid for by William Thomas Bass II. There is a statue of his son, Michael Arthur Bass, or Lord Burton, in the square in front of the church, hidden behind the trees. Carry on up Waterloo Street and turn *right* at the traffic lights, then *left* at the next set of lights into Derby Street.

Sight Ten: The Alfred can be found a little way along; once the brewery tap for Truman, Hanbury & Buxton Brewery, which sat opposite, it is now a Burton Bridge Brewery house. Retrace your steps to the traffic lights and go *straight on*, passing Lidl as the road rises. Go *left* over the bridge. You'll spot the railway station on the right and the former Midland Railway Grain Warehouse No. 2 on the left. Keep going and look left.

Sight Eleven: At the foot of the bridge, the building set back from the road on the left was Allsopp's New Brewery.

Sight Twelve: Opposite is the Roebuck. There is evidence of its Ind Coope past and they usually have Gates Brewery beers on. Keep going down Station Street. If you are lucky, the Last Heretic micropub will be open.

Sights Thirteen and Fourteen: The large white building on the left used to be Ind Coope's offices. The rest of the brewery is set back from the road. A little further on is the Devonshire Arms. Once a James Eadie pub, it was an Ind Coope house in the 1980s and is now owned by Burton Bridge Brewery. Stop at the T-junction with Cross Street.

Sights Fifteen and Sixteen: Either side of Station Street you will see what once was Bass, but now is Molson Coors. To the left is the Bass Middle Brewery and to the right is the New Brewery.

Sight Seventeen: The Coopers Tavern on Cross Street. Here they serve Draught Bass straight from the barrel. This comes highly recommended! Go back onto Station Street and turn *right*. Walk under the bridge.

Sight Eighteen: Bass offices is on the left-hand side. Turn *left* at the traffic lights into Guild Street.

Sights Nineteen and Twenty: Bass Middle Brewery is on the left (look carefully at the modern grey building and you will see a faint Bass sign). The large area on the right with Matalan and Cineworld used to be Bass Middle Yard.

Sight Twenty-One: The copper and Burton Union Set in the National Brewery Centre car park. Ahead is the Magistrates' Court; look to the left-hand side of this.

Sight Twenty-Two: Bass Plough Maltings, which is listed Grade II but is disused and in a very sad state. Turn *left* onto Horninglow Street.

Sight Twenty-Three: The National Brewery Centre, which was once the Bass joiners shop and engineer's workshop. This is worth a visit if you have time; if not, at least pop in the brewery tap and try some of Heritage Brewery Co.'s beers that are brewed on site. Go back to the T-junction but this time keep the Plough Maltings on your left and carry straight on along Horninglow Street. Stop at the buildings immediately after the new police station.

Sight Twenty-Four: The Malthouse was Henry Allsopp's townhouse.

Sight Twenty-Five: The next building, with the impressive raised section at the rear, used to be Samuel Sketchley's and later Benjamin Wilson's Brewery.

Sight Twenty-Six: Carry on, and opposite is a building with a blue door, which is partially obscured by a tree. This is Charles Leeson's townhouse, with the malthouse behind.

Sight Twenty-Seven: Clay House, the site of Joseph Clay's Brewery, is a little further up.

Sight Twenty-Eight: John Thomspon's Brewery is further up on the left-hand side, behind the gates marked 'Anson Court'. Go *straight over* at the lights onto Bridge Street. On the left is the Three Queens – an old coaching inn.

Sight Twenty-Nine: Burton Bridge Brewery is on the right, complete with a pub.

Sight Thirty: Joseph Nunneley's townhouse, at the foot of the bridge, is now a dental surgery. Cross the road at the foot of the bridge. Keeping Nunneley's behind you, *bear left*, taking you behind the Three Queens.

Sight Thirty-One: Benjamin Printon, the town's first common brewer, brewed on this site. Turn *right* at the Halfords garage onto Wetmore Road (previously called Anderstaff Lane), and keep walking.

Sight Thirty-Two: Bass Anderstaff Maltings, now called the Maltsters, is on the left. Go down the left-hand side and you'll find even more maltings. Carry on along Wetmore Road and *bear left* at the fork onto Wharf Road.

Sight Thirty-Three: Thomas Salt's Walsitch Maltings are on the left.

Sight Thirty-Four: The Tower Brewery can be found down the left-hand side on Glensyl Way. The brewery tap is only open on Fridays. Retrace your steps back to Halfords and keep walking; in the distance, on the left, you should see the top of the Bass water tower. Go *straight over* onto the High Street, keeping Spirit Games on your right. On the left used to be Burton Brewery Co., Thomas Salt, Allsopp's Old Brewery, Bass Old Brewery and Worthington's. All are now gone. There is another micropub, the Fuggle & Nugget, next to the church. Pass the Molson Coors offices.

Sight Thirty-Five: Bass Town Houses are on the left with the gates to the Old Brewery. The next crossroads has gastropub The Crossing, which used to be the site of the Blue Posts Brewery. Follow the signs *left* for 'Public Library'.

Sight Thirty-Six: Bass water tower. This area is called the Hay and was once a panorama of brewing. Only the water tower remains. Retrace your steps to the High Street.

Sight Thirty-Seven: The Worthington offices (now occupied by Ben Robinson Insurance). The brewery used to occupy the land opposite, along Worthington Way. Carry on down the High Street into town, pass the T-junction with Station Street and then the Market Place on your left and you'll come to a roundabout with the controversial modern sculpture, the Malt Shovel, which, believe it or not, is actually a spade! Go *straight over* onto Lichfield Street. You'll pass The Dog, who boast the widest range of ales in town. Opposite is where Burton Abbey once stood.

Sight Thirty-Eight: John Bell's townhouse is at 10 Lichfield Street.

Sight Thirty-Nine: On the bend is The Leopard; next to it once stood Charrington's Abbey Brewery but now Sports Direct occupies the space. Follow the path of Lichfield Street to the roundabout (Halfords and Dunelm will be on your left), and turn *right* onto Orchard Street. You will pass Caxton Court on your left. At the next roundabout